SHORT CUTS

INTRODUCTIONS TO FILM STUDIES

BOLLYWOOD

GODS, GLAMOUR, AND GOSSIP

KUSH VARIA

WALLFLOWER

LONDON and NEW YORK

A Wallflower Press Book
Published by
Columbia University Press
Publishers Since 1893
New York • Chichester, West Sussex
cup.columbia.edu

A complete CIP record is available from the Library of Congress

ISBN 978-1-906660-15-4 (pbk. : alk. paper)
ISBN 978-0-231-50260-3 (e-book)

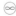

Columbia University Press books are printed on permanent and durable acid-free paper.
This book is printed on paper with recycled content.

Printed in the United States of America

p 10 9 8 7 6 5 4 3 2 1

CONTENTS

ACKNOWLEDGEMENTS

It was my former tutor and now dear friend Rachel Dwyer who suggested that I write this book, and it could not have been completed without her continued encouragement and enthusiasm. I would also like to thank her for her assistance during my research trip to India.

India: At Rajshri Media and Films I would like to thank Rajjat Barjatya for his constant stream of information and correspondence. For information, interviews and stills I would like to thank Akshaye N. Widhwani at Yash Raj Films, Meghna Ghai-Puri at Mukta Arts and Whistling Woods for her inter-view and support throughout the project and, Dharma Productions. Rinki Roy for her lovely hospitality and discussion of her father Bimal Roy's work. Gayatri Chatterjee for her informative insights. Mr Shashidharan and the staff at the National Film Archive, India for opening their treasure troves to me. Thanks to Shapoorji Pallonji for the *Mughal-E-Azam* still; to Shekhar Kapur for the *Mr India* still; and to Roy Wadia for the *Fearless Nadia* still. Finally a huge thank you to Jerry Pinto for his non-stop availability in India whether it be finding the finest Gujarati food in Mumbai or trekking through back alley haunts in search of mythological VCDs.

UK: Stella Bruzzi has always been a huge inspiration since my under-graduate days and I would like to acknowledge the continuous friendship and guidance she has offered over the years. I would also like to thank Laura Mulvey and Michael Allen, Richard Dyer, Stacey Abbott, Janet McCabe and Kim Akass for their guidance during the early stages of this book's development. A special thank you to the Royal Society of Asian Affairs and the School of Oriental and African Studies, University of London, for inviting me to lecture on my work in progress. I would also like to thank the staff at the British Film Institute and the India Records Office at the British Library.

Nasreen Munni Kabir deserves special mention for her pioneering work in bringing the wealth of Bollywood to British television and without whom I would not have fallen in love with Bollywood or have such happy memories of viewing clips and movies with my parents.

My thanks to Yoram Allon at Wallflower Press for inviting me to write this book, and further thanks to him, Jodie Taylor and Tom Cabot for all their support throughout the project.

Friends have expressed enthusiasm and shown much patience during long writing periods and provided much needed companionship during breaks. Thank you for getting me here: Laura Blears, Zeb Buchanan, Cathy Campbell, Luis Carrasquerio, Jake Cassels, Emily Crosby, Rebecca Demott, Michael Dwyer, Adam English, Matthew Francis, Siobhan Flint, Richard Goldthorpe, Darren Haynes, Charlie Henniker, Miikka Leskinen, Arian Levanael, Kate Maddigan, Romily Menzies, Paul Maidment and Sarah Moore, Harriet Osborn, Alex Stolz, Julian Taylor, Roydon Turner, Andrew Utterson, Alan Waller and Lisa Williams.

Special thanks to Kirsi Matikainen and my in-laws in Finland, Markku and Anneli Matikainen. For never-ending support: Hetty Malcolm-Smith.

Mostly I would like to thank my partner Harri Matikainen for keeping me fuelled with smiles, patience and encouragement. Life is wonderful with you.

*This book is dedicated with love to my parents
Valji Savji Varia and Chanchal Valji Varia
as well as my brothers Mukesh, Hitesh, Valji L. and their families.
Thank you for sharing many a Mumbai-made movie and
cultivating a magnificent obsession.*

Jai Saraswati Maa Namah.

INTRODUCTION:
BOLLYWOOD – WHAT'S ALL THE SONG AND DANCE ABOUT?

Bollywood is one of the world's leading film industries enjoyed by millions around the world. Fans flock to cinemas to witness its melodramatic narratives, decorated with very particular pleasures including song and dance. While the West has become familiar with the idea of Bollywood, little may be known about the industry and its movies beyond a certain celebration of kitsch. Bollywood is often derided for its sometimes flamboyant conventions, including the infamous cliché of running around trees. The particular pleasures of these devices may be lost on the uninitiated viewer who is at risk of being overwhelmed by the spectacular and fantastical visions they are confronted with. By understanding and deconstructing these essential ephemera, a far from vacuous cultural product is revealed. Rather, Bollywood is constantly in tense negotiation between tradition and modernity, often providing opportunities for unconventional socio-cultural discussion and even un-conservative solutions.

There have been many academic attempts to discover a specific cultural explanation for the conventions found in Bollywood. This has included anchoring its aesthetics and attributes in ancient Indian dramaturgy such as the *Natsyashastra*, penned by Bharata in the second century BC. Bharata discusses the ways in which specific emotions (*rasas*) can be stimulated through the use of specific dramatic tools, for example the use of shock and comedy in the performance of Sanskrit plays in courtly settings. The text has been referred to by Vijay Mishra (1985), Rosie Thomas (1985) and Asha Kasbekar (1999) in their work on the popular cinema as a potential critical methodology for analysing these movies to understand the particular style of Bollywood and its audience's experiences. But this work refers to a specific historical time, culture and literary tradition that was never

mainstream and largely forgotten by the time of the arrival of cinema. The legitimacy of the claim has been contested by Rachel Dwyer who claims that the only foundations of its use are in the fact that it is 'Indian, ancient and indigenous' and labels it a 'nativist concept' (2002: 67). But if the cinema cannot find its origins in a unique and classical dramatic tradition where does it lie? For Ashish Rajadhyaksha (1987) the harbingers of cinema are to be found in the popular art forms that emerged in late nineteenth- and early twentieth-century colonial India which was in a state of flux due to the expansion of industrialisation and the emergence of new technologies. This created a perfect habitat for growth of new art forms such as urban theatre and the mass production of popular art works of gods and goddesses, still in circulation today. As Rajadhyaksha points out, India's first feature film director, Dadasaheb Phalke, trained and worked across several of these new forms of artistic production such as lithography, its conventions and modes of address eventually influencing his movies (1987: 47–8).

Ravi Vasudevan argues that Indian popular cinema follows the pattern of a 'cinema of attractions' (2000: 133). This term was first coined by Thomas Gunning to describe the inclusion of multiple forms of entertainment in early cinema in the West under the influence of its predecessors such as the fairground as well as other aspects of modernity. But whilst most Western cinemas developed industries with rigorously defined genres, Indian popular cinemas carried on presenting a multitude of attractions. At the apex is Bollywood which has emerged as a movie tradition that functions within a melodramatic framework and has its own unique stylistic conventions. Understanding this framework, and deciphering the stylistic conventions within, is essential for appreciating both Bollywood's numerous attractions and its commercial success.

Bollywood ignites specific pleasures. The cinema's stars are praised for both their versatility and their expertise at playing specific character types as well as their ability to inspire emotional reactions in the audience. Background artistes such as singers, composers, lyricists and dialogue writers and choreographers are held in high esteem. Critics often claim that the audience of these films is largely naïve and easily pleased with what is on offer. But the industry is notoriously volatile, with only a tiny number of films becoming hits out of the hundreds released every year.

Throughout this book I will provide explanations for some of the questions that are often raised by new viewers of Bollywood by exploring the

history and workings of the industry, the narratives and aesthetics of its films, varieties within the genre, the cultural connotations of specific characters, its larger-than-life stars, and its hybrid and surprising fan cultures. I will explain the highly refined and individualistic forms of storytelling which demand more from the viewer than mere passive viewing. Not only in terms of attention to the narrative, but also in sensory and emotional responses: specific genres have specific requirements and so while song and dance will be included across genres, their frequency, mood and visualisation will vary.

To illustrate these discussions, I provide examples of films that I recommend for viewing which highlight some of the key issues that are raised, as well as particular scenes of interest. These films are all readily available for purchase and have been carefully selected to show the works of key directors and also a cross section of production periods, visual and musical conventions as well as stars.

A note on terminology

Sadly, for many regular viewers, Bollywood is at best a guilty pleasure and, at worst, an embarrassing cultural product. Discomfort between the popular Hindi cinema and the state has been seen throughout its history. This was particularly evident in the view of the Indian government following independence in 1947, where it seems to have been reluctant to accept the popular cinema as the national cinema of the new nation. In 1950 Nehru appointed S. K. Patil to head the Film Enquiry Committee. Its report noticed three key developments in the film industry during World War II which included: a shift in the industry's economic dynamics; a need for the government to decide on the type of cinema it should support; and thirdly, what Ashish Rajadhyaksha terms the 'genre question' concerning the issue of national identity and the split between the Hindi cinema, catering for a national audience and the regional cinemas, which had the potential to create tensions through the espousal of regional political and cultural identity (1996: 679). Rajadhyaksha's observations highlight three types of cinema in independent India: Hindi cinema – the national cinema of India; regional cinema – catering to specific language-based audiences; and finally government-supported cinema including Art and 'Middle' cinema (ibid.). It would be the latter that would receive the nod of

approval by India's elite and intelligentsia, with directors such as Satyajit Ray becoming respectable cinematic figures in the West.

The use of the term 'Bollywood' is also a reason why the cinema is not taken seriously. As the term is a play on Hollywood, it simultaneously degrades that which it aims to describe by immediately branding it as a poor imitation, therefore tarnishing its reputation and scaring away any potential for serious analysis. But the term is a double-edged sword. While it has negative connotations, it is also recognised as a global brand with massive commercial power at the box office. Nobody is really sure where or when the term 'Bollywood' emerged. Claims vary from the British press to the Indian intelligentsia, but what cannot be denied is the profusion of the word in the worlds of business, academia and popular culture. But what exactly does it mean?

Efforts to define Bollywood have included 'popular Indian cinema' or 'Hindi cinema'. The term 'Indian cinema' is difficult to apply because India has so many cinematic traditions which all deserve to be differentiated from one another and awarded their own legitimacy, definitions and study. Equally, it is difficult to define Bollywood as Hindi cinema as there are many types of cinema produced in Hindi both in and outside of Mumbai, the city previously known as Bombay, giving the 'B' to Bollywood.

For the purposes of this book, I have decided to define Bollywood as Hindi-language based and populist cinema produced by major studios in Mumbai. But there still remains a problem. Equating this cinema with a specific language risks forgetting its historical roots in Urdu. Urdu writers, poets and lyricists played a vital role in developing the cinema; it is for this reason that I have decided to trace the history of Bollywood back through the early sound period into the silent period, as this is where so many of its conventions were seeded and developed. The pioneers of cinema in India placed great emphasis on its value as a commercial product giving them the opportunity to reach millions. This would eventually lead to its use as an ideological weapon in the anti-colonial struggle ensuring its important role in creating an independent India.

1 HISTORY AND INDUSTRY

During the late nineteenth century, a series of technological and economic changes, including the introduction of the printing press and the building of the railways, spurred a marked increase in India's urban populations, particularly within the middle classes (see Stein 1998). This led to a boom in popular entertainment such as the performing arts and leading this was the Parsee theatre, based in Bombay. The Parsees are descendants of Zorastrians who left Persia around one thousand years ago and who largely settled on the western coast of India. The plays performed by the Parsee theatre groups varied from original works to adaptations of Shakespeare and they incorporated dance, music and drama creating a unique repertoire of urban theatre. The hybrid nature of the Parsee productions had similarities with Hindu performances of stories from religious epics such as the *Ramayana* and popular tales of the exploits of the god Krishna, performed during religious festivals (*lilas*). The conventions of these performance traditions were to blend with the influence of Hollywood and also nationalist and religious images circulating in calendar art popularised by the establishment of an indigenous printing industry (see Rajadhyasha 1987 and Pinney 2004). All of these forces shared a talent for spectacle, visual variety and commercial gain.

In 1896, the Lumiere brothers brought their films to Watson's Hotel in Bombay (see Barnouw and Krishnaswamy 1980: 1). Soon after, documentary films began to be made in India, the major pioneer being Harishchandra Sakharam Bhatvadekar, who filmed the Delhi Durbar in 1903. Several film

exhibitors emerged in this period, including the Madan brothers who shot advertisements as well as dance and theatre shows (see Barnouw and Krishnaswamy 1980: 6–10).

The Silent Cinema

India's first feature film director was Dadasaheb Phalke. Phalke was inspired after watching a film on the life of Jesus. He later remembered himself 'mentally visualising the Gods, Shri Krishna, Shri Ramachandra, their Gokul and Ayodhya' and asking himself 'could we, the sons of India, ever be able to see Indian images on the screen?' (cited in Rajadhyaksha 1987: 48). Clearly there was a political motivation for Phalke who saw the creation of India's own cinema as an important player in the growing struggle for independence. In 1913, Phalke produced *Raja Harishchandra*, a short film based on an episode from the Hindu epic, the *Mahabharata*. The film also featured an all Indian cast and crew (see Barnouw & Krishnaswamy 1980: 12–14).

Most of Phalke's following films were based on Hindu scriptures and folklore. His background was as an artist, magician and publisher whose previous positions included working for the Ravi Verma Press. This gave him an awareness of the visual conventions of popular calendar art, including the use of picturesque framing and religious themes (see Rajadhyaksha 1987: 47–8). In these images, Hindu gods and goddesses were presented in a frontal address – centrally located and gazing out to the worshipper or spectator – following the traditional placing of idols in shrines allowing the devotee to both see and be seen by the holy image, an act known as *darshan*. Both written and oral histories of the early Indian cinema mention worshippers prostrating themselves before the screen on seeing the gods before them (for example Barnouw and Krishnaswamy 1980: 15). It would be easy to judge such behaviour as typical of a naïve and superstitious audience unacquainted with the technologies of cinema and enchanted by the animation of their religious deities; however, this would dismiss Phalke's cinematic brilliance particularly in the field of special effects which always maintain an allegiance to realism. For example, in *Shree Krishna Janma* (1918) Phalke portrays the evil King Kamsa imagining his death at the hands of his nephew, the god Krishna. Kamsa's head leaves his body and hovers above it with mouth wide open; Kamsa simul-

taneously places his hands around his neck as if to check his head is still attached. This moment of both shock and humour not only demonstrates the director's attention to detail but also his conscious effort to make the scene as real as possible.

Financial profits allowed Phalke to establish India's first film studio, Hindustan Cinema Film Ltd in Nasik, a town to the southeast of Bombay. Here, Phalke established a family-run business where he directed and produced, his wife oversaw film processing in the kitchen and their children performed (see Barnouw & Krishnaswamy 1980: 63). His success encouraged other entrepreneurs to follow suite and a number of studios emerged which mainly produced adaptations of religious stories that were advertised as 'Mythologicals'. These studios established themselves in key economic centres, for example Madan Theatres and the Indo-British Film Company in Calcutta and the Kohinoor Company in Bombay (see Garga 1996: 37–9). Alongside the Mythological, several other prominent genres began to emerge including the Stunt, the Social and the Historical. Stunt films included portrayals of physical feats, chases and acrobatics. The Social centred on narratives that portrayed ills in Indian society such as the caste system. The Historical consisted of royal and costume romances.

Despite the bourgeoning film industry, Hollywood still had a massive hold on the Indian market (see Barnouw and Krishnaswamy 1980: 40–2). This was partly the result of its growth during World War I, a period in which British and other European film industries witnessed substantial decline. Hollywood's dominance was a source of discomfort for the British, not only because of its financial power but also because of its potentially corruptive influence upon colonial subjects who would be exposed to negative presentations of characters and morality in the West (see Barnouw and Krishnaswamy 1980: 43). They tackled the problem in two ways.

Between 1918 and 1920, the British implemented stricter censorship rules (see Rajadhyaksha & Willemen 1994: 20–1). Continuing unease led to their establishing Empire Films, a body to promote the production and distribution of British and colonial films throughout the empire. This was followed by the setting up of a short-term enquiry led by the Indian Cinematograph Committee (1927–28). Their report and its associated Evidences give a fascinating and detailed insight into both British and Indian concerns surrounding the industry.

Leading the report was B. T. Rangachariar, a lawyer from Madras (now

Chennai). Other members of the Committee included Indian and British personnel drawn from the industry, the civil service and wider society. The enquiries took place all over India with participants answering question-naires and providing personal accounts and insights (Evidences) (see Barnow and Krishnaswamy 1980: 44–58; Garga 1996: 57–60). The interviewees questioned included Mahatma Gandhi, the leader of India's independence movement, who returned a letter stating that 'The evil that it has done and is doing is patent. The good if it has done any at all has yet to be proved.'[1]

The position adopted by Gandhi must have been disheartening for those in the film industry, such as Phalke, who saw their work as integral to the independence movement. Gandhi's attitude towards the cinema differed from that of his contemporary freedom fighter Rabindranath Tagore, and their conflicting views are of interest if we consider the cinema to be a locus of modernity. For Gandhi, the modern world and its trap-pings were Western imports to be abandoned by Indians. He advocated a return to rural ideals and self-sufficiency. Tagore was a Nobel Laureate from the state of Bengal who was at the forefront in leading a renaissance in Indian art, music and literature, primarily through his establishment of the Shantiniketan school and college in Calcutta. He was staunchly secu-lar and advocated the use of new technologies, scientific advancement and modernisation. Tagore was closely involved with the cinema indus-try, particularly in Bengal. At Shantiniketan he directed dance-dramas of his stage plays and would later compose music for various productions by the Bengal based New Theatres company (see Seth & Seth 1994: 7).[2] Unfortunately Tagore was not interviewed during the enquiries.

The report was finally released in 1928. Rangachariar emphasised the importance of the cinema as an instrument to promote India's popular cultures. In addition, the report called for the establishment of tax and government concessions, alongside the formation of film schools and the setting up of a national archive. When it came to censorship, the com-mittee recommended the prioritisation of censorship, but only for those scenes that would cause friction between communities (see Barnouw and Krishnaswamy 1980: 43–58).

Rangachariar boldly stated: 'It is not only the potential value of the Indian film industry in the financial sense to the country that we lay stress on, but we are firmly of the opinion that it is necessary to remove from the screens the foreign grip' (1928: 61). This caused the three British members

of the committee to term the policies of the dominant Indian members of the industry as 'positively dangerous' (Green, Crawford & Coatmen in Rangachariar 1928: 175). Sadly, it is this statement which made the most impact. The biggest outcome of the report was a further sharpening of the censorial scissors and particularly worthy of the snip were scenes that might evoke anti-British sentiment. Incidentally the publication of the report coincided with the arrival of synch sound in the USA (see Barnouw & Krishnaswamy 1980: 58). This technological development would later increase the indigenous cinema's foothold in the home market, establish regional and therefore linguistically-based production houses and heighten cinema's role in the independence movement, guaranteeing its release from 'the foreign grip'.

Sound Cinema

As with Hollywood, silent films in India had usually been accompanied by some sort of music or sound effects (see Kasbekar 1999). Some of the largest cinemas contained orchestra pits and smaller cinemas would also have musicians as well as narrators who would translate title cards. This would have been particularly important in poor and rural areas with low levels of literacy.

Indian experiments with synchronised sound began in 1930 with the release of a film of Gandhi at a pro-independence cottage industry (*khadhi*) exhibition (see Rangoonwalla 1975: 75–6). India's first sound feature film was Ardeshir Irani's *Alam Ara* (1931), an all-singing all-dancing spectacle. Its production demonstrates the way in which the industry could also produce films for Indian audiences regardless of regional, linguistic and religious differences. The film was based on an Urdu play, its director was a Muslim, and the cast was a mixture of Hindus, Muslims and Anglo-Indians, while the play was recorded in Hindi and Urdu (see Garga 1996: 71–2). *Alam Ara* enjoyed huge success across India, including the south where neither Hindi nor Urdu are widely spoken nor understood, except in centres of large Muslim populations such as Hyderabad. The film set a new standard for India's future popular cinemas and its national success can be regarded as a key reason for the appropriation of the song and dance formula throughout other regionally-based industries, creating what has become a transnational feature throughout India's popular cinemas.

Irani's 'temptation to make a picture in our own language' (1981: 4) was a desire shared by other pioneers. On the same day as the release of *Alam Ara*, Madan Studios released a programme of sound shorts comprising of a Sanskrit prayer, a speech in Hindi and an extract of an Urdu play (see Barnouw & Krishnaswamy 1980: 67). Perhaps this was an attempt by the cinema industry to maintain a sense of pan-Indian consciousness with the potential threat of new technologies to splinter the industry into linguistically specific cinemas. This would have been particularly poignant considering the political inclination of the industry and also because of the increasing religious sectarianism between Hindus and Muslims within the socio-political sphere.

New studios emerged that were based in major cities that serve populations who spoke particular languages. The most prominent were Prabhat Studios in Pune, producing films in Marathi as well as Hindi, and New Theatres in Calcutta, producing films in Bengali. It was during this period that major studios were established in Bombay including Bombay Talkies, Wadia Movietone and Minerva Movietone; and a studio system emerged which followed the pattern of vertical integration used in Hollywood (Garga 1996: 82). Individual studios signed up both production staff and performers and simultaneously invested in distribution networks and cinema halls. Most of these studios produced multilingual films, with the northern-based companies almost always producing films in Hindi and Urdu as well as the local language. Studios also undertook joint ventures and loaned equipment, stages and stars (see Rajadhyaksha & Willemen 1994).

A key figure of interest in this period is Himansu Rai, whose career went through a personal transition in the early sound period. Rai's first sound production was *Karma* (1933), shot in English and aimed at an international audience. The movie failed and even when the film was released in Hindi the audiences were still small. This encouraged Rai to concentrate on the Indian market and in 1934. He founded Bombay Talkies which became the leading studio in Bombay with its own soundproof studio and recording expertise (see Garga 1996). Rai's wife, Devika Rani, who herself had previously worked in European cinemas, starred in the studio's films and Ashok Kumar became its leading man and an actor whose fame would continue in the post-independence era. He starred opposite Devaki Rani in *Achhut Kanya* (1936), a film which dealt with the evils of the Hindu caste system and considered to be a classic of the colonial period (see Dwyer 2005: 12–13).

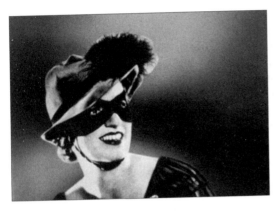

Queen of the stunt movies, Fearless Nadia in her distinctive Zorro mask, ever ready for another swashbuckling adventure.
© Wadia Movietone

Wadia Movietone was set up by the Wadia brothers in 1933. It was most famous for its stunt films starring 'Fearless Nadia'.[3] Nadia, whose real name was Mary Evans, was an actress of Greek-Australian descent who was easily identifiable in films by her Zorro mask, shorts, leather boots and whip. She often undertook great physical feats including stupendous fight scenes where she would throw opponents over her shoulders, undertake horse races and rescue damsels in distress. Sohrab Modi founded Minerva Movietone in 1936. Modi had been an artiste in the Parsee theatre and in 1935 had established the Stage Film Company to film his plays and present them in cinemas (see Garga 1996: 122). His theatrical experience probably accounts for his grandiose productions which mainly consisted of Historical films including the 1939 release *Pukar* (a film based on the life of the Mughal emperor Jehangir, and *Sikandar* (1941), based on Alexander the Great's campaign in India.

The development of language-based production houses also brought with it an emphasis on regional interests, and resulted in the emergence of the Devotional film which portrayed the lives of saints whose stories were – and still are – very much a part of local cultures. Many of these figures also had a secular appeal as they had championed issues such as Hindu/Muslim unity.

The outbreak of World War II in 1939 led to tighter restrictions on both censorship and film stock. An emerging black market allowed private investors to enter the industry. These individuals were often able to offer huge salaries to stars, often on a back-hand basis. This shift was to summon in

the heightened importance of the star (see Barnouw & Krishnaswamy 1980: 127–30. All of these factors eventually led to the collapse of many of the existing studios. As the war progressed, the government demanded that a certain percentage of films be made in support of the war effort (ibid.).

Despite apparently submitting to these pressures, moments of deviance did occur. This is most evident in *Kismet* (Gyan Mukherjee, 1943) when an apparently pro-war and anti-German and Japanese song is being performed on stage in a theatre. The song begins with an outline of India superimposed on the stage's curtains, which open to reveal soldiers marching around a huge map of India singing lines warning invaders to stay away. The next verse sees Hindu, Muslim and Sikh women standing in unison before replicas of historical and religious monuments with the heroine singing the proclamation: 'to claim this land as yours is an atrocity'. The finale has a personification of Bharat Mata (India as a goddess) being deified as she raises her hand in blessing, and closes with a high-angle shot of the soldiers surrounding a map of India, rifles pointed outward and at the ready. One can only wonder how this scene survived the censor's scissors.[3]

CASE STUDY: A Throw of Dice (Franz Osten, 1929) / *Dr Kotnis Ki Amar Kahani* (R. V. Shantaram, 1945)

These two films demonstrate the tension between creating a cinema with national relevance and one which would appeal to international audiences. *A Throw of Dice* deserves special mention as it is one of the few silent films produced in India that is widely available. An Indian, German and British co-production with director Franz Osten (formerly of EMELKA studios in Germany), it was the third in a series of films beginning with *Light of Asia* (1925), based on the life of the Buddha, followed by *Shiraz* (1928), based on the love between the Mughal Emperor Shah Jahan and his Queen Mumtaz, for whom he built the Taj Mahal. While these films saw substantial success abroad – due to their lavish and picture-postcard depiction of the East – their impact on the Indian market was slight (see Barnouw & Krishnaswamy 1980: 97–8).

Spectacle is the predominant factor in *A Throw of Dice* as it blends the melodrama of D. W. Griffiths with the Oriental fantasy of Cecil B. Demille. The story echoes one of the key plots in the Hindu epic, the *Mahabharata*,

that centres on a corrupted game of dice. In this text the protagonist's addiction to the game leads to the shattering of traditional values and subsequently war. However, in *A Throw of Dice* the moral tensions (which would have been particularly appealing to the domestic audience) are sunk in a quagmire of superfluous splendours (appealing to a foreign audience). A great deal of screen time is given to the depiction of the exotic: temples, palaces, jungles and hunts for wild beasts. The battle scenes in the film are spectacular and involve casts of hundreds, including military elephants.

It could be argued that this tension in the film encapsulates the industry's own tension with colonialism. What *A Throw of Dice* represents is an attempt to keep all audiences pleased: the domestic, the colonising power and the international. In essence it tries to be everything to everyone but in doing so fails to please anyone. But the main reason for the failure of *A Throw of Dice* to connect to domestic audiences was its dilution of well-known stories and themes which, as the Cinematograph Committee report stated, was so important to Indian viewers. As already discussed, once sound entered cinema, the public desire to hear Indian languages expanded its appeal to domestic audiences. The industry boomed, locally and nationally, and this guaranteed huge revenue from home audiences. As well as the added appeal of language, the audience understood deliberate and coded messages, so whilst a film was aiming to meet the requirements of colonial demands and controls, it was also betraying it with anti-colonial propaganda. In other words, sound allowed the injection of an anti-colonial agenda. But the main reason for the failure of *A Throw of Dice* to connect to domestic audiences was its dilution of well-known stories and themes which, as the Cinematograph Committee report stated, was so important to Indian viewers.

Dr Kotnis Ki Amar Kahani remains one of the unsung masterpieces of pre-independence Bollywood. It tells the real life story of Dr Dwarkanath Kotnis (played by the film's director, Rajaram Vankudre Shantaram), a newly-graduated Indian doctor who undertook a Congress Party mission to aid Chinese victims of the Japanese invasion in 1937. The film's production was backed by the British who saw it as a way of whipping up support for the war effort (see Barnouw & Krishnaswamy 1980: 132–4). However, there are moments when the director seems to subtly instill a sense of Indian nationalism. At several points in the film we see a ring embellished with a

Publicity poster for *Dr Kotnis Ki Amar Kahani*. Note the image of the Buddha in the background suggesting the historical and cultural links between China and India. © Rajkamal Kalamandir

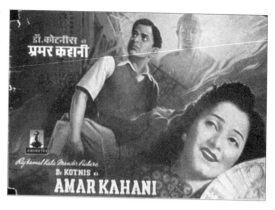

map of India. The ring is passed down to Dr Kotnis by his father and he in turn gives it to his love interest, the Chinese nurse Qinglan Gu (Jayashree) (see Chakravarty 1993: 41). Its passing between characters who have close relations suggests the ring and therefore India is something only to be held in the hands of those who can be fully entrusted with its care.

The subplot of the film concerns his romance with Qinglan, whom he marries. Dr Kotnis dreams of taking Qinglan to India but sadly he passes away on the battlefield; Qinglan gives birth to a son and takes him to his grandparents in India. The film is contained within a perfect circular narrative that begins with the young Dr Kotnis returning to his hometown after graduating from medical school. His voiceover describes the town and its inhabitants with complementing shots. At the end of the film, when Qiniglan brings their son to visit his grandparents, Dr Kotnis's voiceover is heard again repeating the lines heard at the beginning. It feels as if the town has stood still in time despite an ever-changing external world: Indian traditions of home and hearth remain solid and untouched, the new is sheltered and absorbed but its core never shaken. At the end of the film an image of Dr Kotnis is shown and the soundtrack allows the film to deviate from its funder's intention of being a pro-war propaganda film: A Hindu prayer-like chant is sung to a superimposed lamp circulating before the image of Dr Kotnis, deified as a national hero.

In this film, 'Indian-ness' is given international importance. Dr Kotnis embodies the nation acting autonomously on an international stage. Although he dies, he is elevated to the level of an internationally recog-

nised hero who takes his place in history and heaven. Qinglan's adoption by the Indian town also has an important message; it proves that just as India should reach out it could also absorb and accommodate, sheltering those in need. But above all else, it is Dr Kotnis's hometown which is most haunting. The town is a metaphor for India, the home is a metaphor for Indians and its occupants a metaphor for Indian-ness (tradition, culture, customs), proving that India (the country and the people) shall pull through, adopt to change and be preserved in any situation.

Following the end of World War II in 1945, the process of decolonisation led to the partition of India in 1947. Areas in the Punjab and Bengal with dominant with dominant Muslim populations were created into the new states of East and West Pakistan. Partition also led to the fragmentation of the once cosmopolitan workforces of Calcutta and Lahore: Muslims leaving Calcutta to move to East Pakistan and Hindus leaving Lahore now in West Pakistan, to move to India. Many of the workers from these industries moved to Bombay and these migrants brought new sources of investment and also technological and creative skills. The prominence of Hindi across northern India and its adoption as one of the new national languages of independent India heightened its status. During the 1950s the Bombay-based Hindi film industry was to blossom into what Rajadhyaksha has called 'that most enviable of national possessions, a cultural mainstream' (1999: 678).

The 1950s and 1960s

The films produced during the 1950s are particularly important because they provide an insight into cultural attempts to construct a post-colonial identity both on an individual and collective level. Some of these films are attempts at creating new myths of the nation, but they also aimed to provide a social critique of Indian society. As Rajadhyaksha (1998: 679–81) notes, many of the workers in the Bombay industry had their roots in the Indian People's Theatre Association (IPTA) which was founded during the struggle of independence and shared many of the social and cultural concerns of the movement. Its political allegiance lay with socialism and its aesthetic stance was realist. Its work during the war years and early independence period focused not only on cultural traditions but political issues of regional importance. This group included the screen-writer K. A. Abbas who was to go on to write Raj Kapoor's super hits *Awara* and *Shree 420* (see below)

both of which contain acutely anti-capitalist messages and went on to be huge successes in the Soviet Union (see Rajadhyaksha 1996).

The 1950s is defined by the works of the 'Big Four' directors: Guru Dutt, Mehboob Khan, Bimal Roy and Raj Kapoor. These directors created a film style which was not only unique to India but was also to surpass the success of Hollywood in many parts of the world. Their films also demonstrated a great diversity of stories, themes and styles. In 1957, Mehboob's *Mother India* became India's first film to be nominated for an Academy Award (see below). Bimal Roy showed particular sensitivity in his work which blended elements of the popular cinema with influences from European schools of Realism. His narratives often focused on downtrodden members of society; his socialist leanings are clear in the film *Do Bigha Zamin* (1953) which tells the tale of Shambu who, due to changing economic circumstances, moves from his rural home to Calcutta where he works as a rickshaw puller in order to pay back debts to his landlord. Money is seen as particularly evil in an infamous racing scene where Shambu's passenger offers him more and more cash to pull his rickshaw ever faster, eventually leading to an accident that cripples him. The tragedy of the rural poor is heartbreaking when Shambu returns to his village only to find that the landlord has already ordered the construction of a factory bringing an end to rural life.

Despite the industry's high production output and its commercial success both in India and abroad, it had an ambivalent relationship with the government, whose ideas of a modern India differed from those being projected on the screen. The criticism of modernity in *Do Bigha Zamin* was at odds with post-colonial India's political ambitions. In 1951, Nehru launched his five-year plan to increase the use of mechanised technology, including the building a series of dams which he saw as the 'temples of modern India'.

The lack of direct government regulation of distributors and exhibitors allowed these sectors to hold the industry hostage through loans offered to producers. Madhava Prasad, who considers that the consensus has remained unchanged, explains the process concisely as the

> minimum guarantee system which is supposed to assure the producer a minimum return of on each film, is also not as favourable to producers as it appears. The amount that is fixed as the minimum guarantee in this transaction is usually the amount loaned by the

distributor to the producer during the making of the film. As a result the producer often gets no revenue from a film after production because the minimum return has already been given in the form of loans. (1998: 41–2)[4]

So the industry was at the mercy of a complicated funding formula, without any government support or regulation. Whilst the government had major issues with the popular Bombay-based cinema, or Bollywood as we shall now call it, this period is recognised by fans as a Golden Age that produced films which were seen to promote 'Indian' morals and values, and where the music, costumes and sets are perceived to be more 'Indian' than later films. Fans often mention the word 'innocent' when describing these films. But memory and nostalgia play a role here and perhaps so does the abundance of black and white, which in retrospect seems so humble in comparison to the bright colours of Eastman film and Technicolor, which were to be widely used by the 1960s.

Technological advances in colour catalysed changes in narrative emphasis and provided new focuses of visual pleasure evidenced by an emerging fascination with the lifestyle of the urban super-rich and the spectacle of foreign locations. Colour film stimulated the blossoming of the romance genre through films such as Yash Chopra's *Waqt* (1965) and romatic comedies like *Kashmir Ki Kali* (Shakti Samanta, 1964) and *An Evening in Paris* (Samanta, 1967). At times these films have sections that appear to be promotional tourist films tempting the audience with romantic landmarks and glamorous locations filled with consumerist trappings.

1964 saw the release of Raj Kapoor's first colour film, *Sangam*, starring himself, Rajendra Kumar and Vyjayanthimala. The story was a love triangle set in India but with most of the song and dance numbers set in London and Switzerland, setting the trend for the use of foreign settings. The film is also infamous for Vyjayanthimala's appearance in a red swimsuit, important as it demonstrates how the introduction of colour emphasised the erotic potential of the female star heightened through the increased importance of the role of make-up and costume and its relationship to the body. An important issue here is the intrusion of what is seen as 'Western' immorality including capitalist excess and sexual vulgarity. Perhaps this explains why the mid-1960s onwards is popularly considered to be a period of decline for the industry where it lost much of its 'innocence'.

CASE STUDY: Pyaasa (Guru Dutt, 1957) / *Aradhana* (Shakti Samanta, 1969)

Below I discuss two films which demonstrate the struggle within cinema in the years following independence to decipher Indian identity at personal, familial, community and national levels. Also, whilst Bollywood films are often seen as saccharine, these two films demonstrate its ability to present and discuss uncomfortable themes such as alcoholism and prostitution (*Pyaasa*) or illegitimate children and single mothers (*Aradhana*).

Guru Dutt directed and starred in several films including *Pyaasa*. This was his biggest commercial success and his inability to recapture this glory caused him to plunge into depression and finally suicide (for further reading on Dutt see Kabir 1997). Vijay (Dutt) is a disenchanted poet who is forced from his home by his brothers who regard him as a lazy scrounger. After being ostracised, his path crosses that of his college sweetheart Meena (Malha Sinha) who is now married to the rich publisher Mr Ghosh. Dejected, Vijay meets the prostitute Gulabo (Waheeda Rehman) with whom he falls in love. A case of mistaken identity leads to Gulabo believing that Vijay is dead. In homage to her (presumed dead) lover, she takes his poems to Mr Ghosh who publishes them, earning him and Vijay's brothers a fortune. Vijay tries to prove that he is still alive but his brothers are scared of losing their newly-earned wealth and accuse him of being an impostor. He is incarcerated in a mental asylum, but escapes with the help of his friend Abdul (Johnny Walker). Vijay appears at a memorial service held in his honour shocking Mr Ghosh as well as his brothers who are forced to acknowledge him. Unable to deal with the materially obsessed world (most evident through the changed attitude of his brothers towards him), Vijay claims he is someone else and leaves the world he has known to begin a new life with Gulabo.

Dutt's characteristic use of chiaroscuro reflects Vijay's inner turmoil especially in the dream sequence where he and Meena remember their love. Visually this scene is an escape from the darkness and shadows that permeate most of the film. The scene is especially poignant as the 'light-relief' only illuminates Vijay and Meena's unrequited love. The falseness of their relationship is personified in Meena's simulacrum-like movement when she disappears from the scene.

The use of songs wraps in tidily with the poet's story. The song '*Aaj Sanam Mohe Ang Laga Lo*' ('Lord take me in your arms') is performed by

a mandali (religious musical group). These words also speak for Gulabo who is seen slowly but surely approaching Vijay, desperate to make contact but in the end unable to bring herself to touch him. The parallels drawn here between the love of the holy woman for the divine and the love of the prostitute for a mortal mix the sacred with the profane and in doing so Dutt emphasises the purity of love no matter who or what the lover and the beloved are. The theme of purity emerges again towards the end of the film. A drunken Vijay roams through a red light district whilst singing '*Jinhe Naaz Hai Hind Par Wo Kahaan Hain?*' ('Where are the protectors of

Characteristic chiaroscuro engulfs Guru Dutt as Vijay holding Gulab (Waheeda Rehman) in a publicity poster for *Pyaasa*.
© Guru Dutt Films Ltd

India?'), Close-ups of Vijay cooling his face with a glass of alcohol are intercut with images of prostitutes and urban squalor. The lyrics are particularly poignant as the film was released ten years after independence; they can be seen as a political commentary on independent India and the inability of the nation to meet the expectations once hoped for in the colonial past. *Pyaasa* deals with characters who are already rejects from the established stronghold of family. Neither character can fit into their surroundings but as a young, childless couple they are given the potential to set up a life of their own. In many ways our second film *Aradhana,* although more of a traditionally 'Bollywood' film, is the more socially challenging of the two as it deals with the plight of the illegitimate child.

Arun (Rajesh Khanna), a pilot in the Indian air force, falls in love with Vandana (Sharmila Tagore). They are secretly married in a temple. Although they have God as their witness, the absence of family and community means that their marriage can never be recognised by society. Later, the couple are caught in a rainstorm and spend the night in a log cabin where

their marriage is consummated. Vandana falls pregnant but Arun is killed in a plane crash. Unable to prove her marriage, she moves to the city where she gives birth to a son, Suraj, who she is forced to have adopted. Vandana finds work as his nurse and carer until she is framed and imprisoned for murder. Years later she is released and is reunited with her son.

Aradhana deals with a young woman who begins life in a middle-class family setting but whose life changes through a series of unfortunate events. Traditionally speaking, as Vandana is a young woman of marriageable age, she is a commodity that should be untouched and unflawed. She also embodies moral and social responsibility. Her mistakes lead to her being ostracised from the traditional world she knows, and she spends a lifetime trying to balance her karmic scales. Whatever period of life Vandana is in she will always be a social outcaste; as a single and 'unmarried' mother, Vandana is the pinnacle of shame. As a single working-woman her status is dubious and she is an easy scapegoat and target; her only comfort comes in old-age. One cannot help but feel that the film is pointing out the unfair treatment of women in society by presenting a character who committed no intentional sin but whose situation was misunderstood: society still demands she atones for her accidents, missteps and cruel twists of fate which come upon her.

Aradhana was also famous for its super-hit songs. These are largely set during Arun and Vandana's romance in the Himalayas. In the popular imagination the snow-capped mountains, cool climate and green hills suggest wealth, leisure and fertility. The evocation of a romantic paradise comes across in the song '*Gun Guna Rahe Hain Bhavre*' ('Busy buzzing bees') resplendent not only with buzzing bees but also vibrantly coloured bougainvillea and plenty of opportunities to roll around in snow and enjoy wide shots of mountain scenery. Similar scenes are seen in the song '*Kora Kagaz Tha*' ('This blank paper') with the couple dancing between golden marigolds and trees.

As well as the utopian settings, the visualisation of these romantic songs feature classic representations of the hero and heroine from the colour films of the 1960s. The hero is clean-shaven, of medium build and wears Western clothes. The heroine is slim and wears a sari, her eyes accentuated with thick eyeliner and hair piled up in a high backcomb. At first the lovers appear to be ideal manifestations of either sex – handsome and beautiful. However, there is much more going on upon the surface.

Although he appears to exemplify the handsome young lover, Arun's Western dress and youthful appearance suggest a boyish naivety, seen in his agreeing to wed away from society. Vandana's appearance is even more ambiguous. Her Western-influenced hairstyle and exaggerated make-up display an apparent sophistication and knowledge of external fashions, consumerism and therefore modernity. But, she remains strapped down in her sari, a symbol of tradition and formality to which she – especially as a woman – will always be bound.

The 1970s and 1980s

Several of the hugely successful films of the 1970s use the young male as a locus for familial as well as socio-political and economic tensions, reflecting contemporaneous economic and political turmoil, including Prime Minister Indira Gandhi's declaration of a State of Emergency from 1975 to 1977. Indeed, the mid-1970s is seen as a period when the industry descended into violence, with narratives orientated towards lower-class male audiences who connected with the phenomenon of the 'angry young man' (see below). This character was defined as a poor, working-class and urban man who becomes increasingly frustrated with and rejected by society. This leads him into the underworld and a life of criminal activity. Several of these films include Bollywood's biggest superstar Amitabh Bachchan, including *Zanjeer* (Prakash Mehra, 1973) and *Deewaar* (Yash Chopra, 1975).

The 1980s proved to be one of the most difficult times for the industry. Manjunath Pendakur discusses the apparent crisis facing the industry in the mid-1980s with the double onslaught of video piracy and a booming television industry. During this period the industry was handicapped by its lack of success overriding the existing problems of lack of government recognition, and a decline in cinema halls for exhibition. In the mid-1980s, producers lost around Rs 1,200 million and the finger was pointed at the onslaught of video (1981: 70). Video also crippled the industry through piracy, and the growth of the home video market led to the demise of the exhibition of Bollywood films in cinemas. During this period women and families stayed at home and cinema audiences became overwhelmingly male, and were served films with poor production values and a penchant for providing gratuitous and perverse pleasures, in particular rape scenes. The depiction of rape is very graphic, with much screen time being used

to show the villain's chase, the cornering of the woman and her pleading for mercy. These scenes are made more disturbing as the camera often takes the position of the rapist, sadistically lingering on the victim's face in close-up. As Lalitha Gopalan (2002) has highlighted, these films often become 'avenging' narratives where the woman seeks revenge on the rapist after state institutions fail to administer justice.

The early 1980s left a mere handful of films which were major successes including the gangster-chic *Qurbani* (Feroz Khan, 1980) with its bosanova and synth-encrusted disco super-hit '*Aap Jaise Koi Nahi*' ('There's no-one like you my love'). Another notable film is the costume drama *Umrao Jaan* (Muzaffiar Ali, 1981), an adaptation of an Urdu novel published in 1899 by Mirza Mohammad Hadi 'Ruswa', tracing the fall of Lucknow to the British through the eyes of a courtesan (see below). The late 1980s was to bring relief for the industry as new stars established themselves and narratives shifted away from violence towards lighter-hearted themes and romantic plots.

CASE STUDY: Bobby (Raj Kapoor, 1973) / *Mr India* (Shekhar Kapur, 1987)

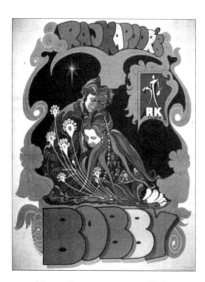

1970s hippy culture, synonymous with Goa, seeps into this publicity poster for *Bobby*.
© R. K. Films Ltd

Bobby is one of the great teen romance movies of Bollywood. Raju (Rishi Kapoor) is the son of wealthy parents. He falls in love with Bobby (Dimple Kapadia), a girl from a poor background. Whilst the lovers are of different religions (Hindu and Christian respectively), this is not seen as a problem. Instead it is their social status that is the cause of conflict, particularly for the parents. Indeed, the film can be seen as a criticism of the corrupting power of money, especially its effect on parents, who are unable to hold-up traditional expectations of duty and behaviour. Bobby's father is a loveable vagabond, a

reoccurring character in Kapoor's films, and the family is poor but loving, kind and liberal while Raju's family is obsessed with financial gain and social status. Raju's father is often away from the home on business whilst his mother has no maternal inclination.

The class of the families is linked to the moral environment that they inhabit and this comes across in a number of song and dance scenes. During the Easter festival, Bobby's family and community partake in an outside street fair where the presence of family and friends sanctifies the singing of a duet between Raju and Bobby. In comparison, the parties that are organised by the acquaintances of Raju's family take place inside homes that are sealed off from the outside world, where ideas of both personal and social morals collapse. This is a world which might have been regarded by a contemporary audience as infused with Western immorality, particularly highlighted during Raju's birthday party as the combination of masked dancers, hedonistic music and swirling camera movements build up into a frenzied crescendo.

Kapoor's apparent condemnation of Western morality is more ambiguous when it comes to Bobby. The director seems to have increased the risks he took in eroticising the female body. Bobby is often seen wearing mini-skirts and also wears a two-piece bikini. It can be argued that these risqué moments are more palatable due to Bobby being a Christian and therefore outside the constraints of traditional codes of conduct that would be expected of girls from other religions such as Hindu. The film's setting in Goa (a place exposed to greater foreign influences through being a popular tourist attraction) also contextualises her appearance.

Just as *Bobby* was Bollywood's first teen romance film, *Mr India was* its first superhero film. It also indulges in the same hedonistic pleasures of Westernised music, dance and costume. However, the attitude towards Western morality is more ambivalent. The setting is no longer a society which needs to be held together via placing the bourgeois family back on path; here, the ideal of the family is defunct. Set in Bombay, the film's central protagonist is Arun (Anil Kapoor), a loveable vagabond with a heart of gold who looks after a group of orphans. He becomes embroiled with gangsters linked to the underworld don Mogambo (Amrish Puri) who plans to take over India. Arun gains his superhero power when he discovers an amulet that can make him invisible. Similar to American superhero comics and their Hollywood adaptations, his love interest Seema (Sri Devi) does

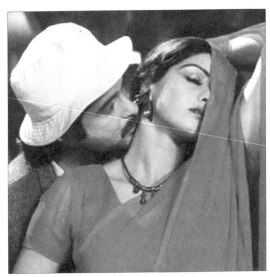

Arun (Anil Kapoor) embraces Seema (Sri Devi) as her sari demonstrates the erotic strategies of veiling and unveiling. Still from *Mr India*. © Boney Kapoor

not realise his true identity but when she discovers the truth, she joins forces with him to thwart Mogambo's plans.

On first viewing, *Mr India* may be seen as a 'copy' of Hollywood films, an accusation that is often made of Bollywood films, denying the cinema legitimacy. Mr India is a superhero narrative in the vein of comic book heroes in Western popular culture. Mogambo's den is very similar to that of the villains in James Bond movies with an underground chamber including high-tech equipment. The film also plays homage to Hollywood, through Seema's impersonation of Chaplin including sped-up film as well as a nod to *The Sound of Music* (Robert Wise, 1965). However the situation is much more complicated and there is great amount of homogenisation that occurs. Unlike most Western superheroes, Arun is not a teenage geek and instead is a rough and ready male already prepared to take on a fight. Bollywood is also frequently honoured. Homage to the Mythological genre occurs when an invisible Arun grabs a statue of a mace-wielding Hanuman (the monkey god from the Hindu epic, the *Ramayana*) and whirls it around the room beating up the baddies in his path. In another dramatic moment, the invisible Arun takes a whip and shapes it into the shape of a danc-ing cobra, perhaps in homage to Sri Devi's previous snake film roles (see

below). Sri Devi is one of the few actresses to be acknowledged for her comic abilities and she shows these off – in particular her stupendously rubbery face – in the showstopper '*Hawa-Hawaii*' ('The girl from Hawaii').[5] This song and several lines in the film, including the lyric 'Bijli Ki Rani' ('Queen of the lightning') and Mogambo's tag line 'Mogambo khush hua' ('Mogambo is happy'), have become essential comic references in Bollywood film culture. The film even has its own Facebook group.

The end of the 1980s marked the beginning of the 'romantic revival' signalled by the release of *Qayamat Se Qayamat Tak* (Mansoor Khan, 1988) and the hugely popular *Maine Pyar Kiya* (Sooraj R. Barjatya, 1989). These films embraced young romance within the context of the upper-class Hindu family. *Maine Pyar Kiya* focuses on a romantic love born of friendship, de-eroticising non-familial love between an unmarried young couple, therefore removing any opportunity for sexual transgression allowing the film to be suitable for a family audience. This is also achieved through displacing the audience's erotic gaze from its traditional occupation with the female body to the male body. The heroine's body is almost asexual as she portrays the idealised young Hindu woman who displays behaviour which, traditionally, any respectable family would desire of their daughter or daughter-in-law. In contrast, Salman Khan's incredibly muscular body is shown throughout the film, particularly in scenes of him exercising in his bedroom that is filled with consumer items including a stereo, sports memorabilia and a poster of Madonna. These objects suggest that an indulgence in travel and consumerism is part of the normal life of the modern well-to-do and young urbanite. The success of this film launched Salman Khan as a major hero and alongside several other emerging stars he was to become one of the great box office draws of a romantic revival which was to flourish into the 1990s.

The 1990s and 2000s

The 1990s was to provide Bollywood with two of the most successful films in the industry's history – *Hum Aapke Hain Koun...!* (Sooraj R. Barjatya, 1994) and *Dilwale Dulhaniya Le Jayenge* (Aditya Chopra, 1995). These films follow the same blueprint as *Maine Pyar Kiya*, focusing on a romantic love affair between a young couple which is eventually endorsed by the bourgeois Hindu family. Lasting over three hours and containing thirteen songs, *Hum Aapke Hain Koun...!* marked a backlash by the industry against

the video and emerging cable markets through its use of video hold-back. Initially only one print of the film was released, exciting public interest and guaranteeing audiences. After this more prints were gradually dispersed, making this a successful coup and future policy for the industry (see Dwyer 2005: 114). These films not only reflected the aspirations of the emerging middle classes in India but also boosted the popularity of Bollywood amongst younger audiences in the Diaspora. For both audiences, the films were able to demonstrate ways in which tradition and modernity could be married within Indian and, in particular, well-to-do Hindu families.

While the 1990s is often associated with the romantic revival, there were also a number of edgier films often concentrating on controversial subjects such as the Bombay underworld as in *Satya* (Ram Gopal Varma, 1998) or terrorism as with *Dil Se* (Mani Ratnam, 1998) to be discussed below. Both of these films were directed by filmmakers from the Telugu film industry (based in the southern state of Andhra Pradesh) and they are widely considered to have had a great influence in bringing a gritty realism to the industry, not only through the use of political themes but also by setting new technical and artistic benchmarks particularly in cinematography and in music, the latter most prolifically by the Academy Award-winning composer A. R. Rehman.

In 1998 Bollywood was finally awarded industry status by the Indian government and this brought about significant changes. Films could now receive investment from established national and international sources. These included banks, tourist authorities and producers of consumer products. However, this legitimacy proved to be a double-edged sword. While the opportunity for multiple investors allowed heightened production values it can also be argued that it heightened the risk for producers who would have to attain higher success rates to ensure they made significant gains once profits had been allocated to investing partners. Perhaps this is one of the reasons for the shift in the types of films produced, which through the use of themes, style and language seem geared more and more towards an international audience.[6]

The new millennium brought with it a new confidence particularly on the international stage when *Lagaan* (Ashutosh Gowariker, 2001) was nominated for an Academy Award in 2001. *Lagaan* was the first in a spate of nationalistic films that emerged in the 2000s. These movies deal with a number of issues including the colonial period represented through histori-

cal or fictional events. They include bio-pics of freedom fighters including *The Legend of Bhagat Singh* (Rajkumar Santoshi, 2002) and *Mangal Pandey: The Rising* (Ketan Metha, 2005), a film based on the Indian mutiny of 1857. Films depicting post-independence tensions with Pakistan have also been popular with a number of movies dealing with international terrorism including *Fiza* (Khalid Mohamed, 2000) and *Fanaa* (Kunal Kohli, 2006).

In sharp contrast to this was the continuing trend for films dealing with the lives of the rich and increasingly global Indian urbanite. These films included Farhan Akhtar's debut *Dil Chahta Hai* (2001) tracking the personal journey of four twenty-something upper middle-class male friends which became a smash hit with young metropolitan audiences. The rise of India as a global economy with migrant communities living abroad has been addressed in a number of films including *Salaam Namaste* (Siddharth Anand, 2005), set in Australia, and *Kal Ho Naa Ho* (Nikhil Advani, 2003), set in New York. The subject matter of these films varies widely from the controversial to the traditional. *Salaam Namaste* tells the story of a couple having a baby outside of wedlock. *Kal Ho Naa Ho* is concerned with the continuation of traditional Indian and extended family values wherever the new geographical location may be (in this case New York). One film which bucked the trend of a foreign location and had massive success in India was *Munnabhai M.B.B.S* (Rajkumar Hirani, 2003) which tells the story of the comic mafia don Munna (Sanjay Dutt) who pretends to be working as a doctor in his own hospital until he is exposed to his parents by his potential father-in-law. The film's biggest appeal is in its lack of moral judgement. Nothing is black and white; instead the world and its inhabitants move through shades of grey. In a profession overcome by stuffy bureaucracy and clinical methodologies, Munna takes a 'back to basics' approach by emphasising human interaction and emotional bonding through his use of 'jhadoo ki jhappi', literally 'magic hugs'.[7]

CASE STUDY: Dilwale Dulhaniya Le Jayenge (Aditya Chopra, 1995) / *Lagaan: Once Upon a Time in India* (Ashutosh Gowariker, 2001)

Dilwale Dulhaniya Le Jayenge is the longest-running film in Indian cinema history, having a non-stop run since its initial release in 1995; in 2012 it is still playing at the Maratha Mandir cinema hall in Mumbai.[8] The film pushes the socio-geographical boundaries of the romance to include the Diaspora

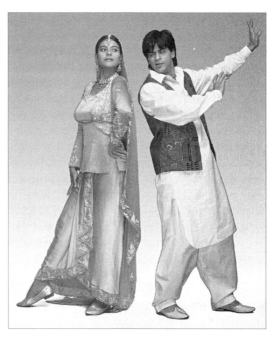

Simran (Kajol) and Raj (Shahrukh Khan) present themselves as the modern romantic couple whose hearts remain Indian. Publicity still from *Dilwale Dulhania Le Jayenge.* © Yash Raj Films

who are key protagonists in the film. British-born Indians Raj (Shah Rukh Khan) and Simran (Kajol) meet whilst travelling across Europe. Raj must convince Simran's family that they should be together, despite her father's wish for her to marry the son of his best friend in his native Punjab.

Raj and Simran symbolise young, internationally-based Indians who have the right to fight for love as well as indulge in all the trappings of consumerism, including travel and fashion. The film questions the prerequisites needed for individuals to define themselves as Indian and seems to conclude that identity is not just based on one's country of birth but also on one's cultural convictions. These issues had timely relevance beyond India, reflecting the coming of age of the first generation of British-born Indian Diaspora in the UK. It was also the period that saw a new economic migration from India to Europe and North America as well as the Middle East and South-East Asia.

Risk, trial and proving oneself are seen as worthy actions whilst understanding and encouragement comes from those you may least expect. Facing

pressure from her father, Simran is pushed to follow his wishes and it is her mother who convinces her to run-away with her true love rather than face a marriage without love. The actions that Raj undertakes to gain acceptance from Simran's family prove that he is prepared to die for his love, therefore proving that romantic love is a tie that can bind as strongly as tradition.

The film's financial success marked a turning point for the industry. It heralded the return of lucrative foreign audiences and established 'Bollywood' as a global brand. *Dilwale Dulhaniya Le Jayenge* renewed confidence in the industry. Greater revenue meant greater investment and also a general upping of standards and expectations to create films appropriate for international audiences.

Lagaan: Once Upon a Time in India is set in 1893 in colonial India. Captain. In 1893, Captain Andrew Russell (Paul Blackthorne) challenges the impoverished villagers of Champaner to a game of cricket. If they win they shall be free from paying taxes for three years and if they lose they will have to pay triple. The young and haughty Bhuvan (Aamir Khan) accepts the wager, much to the dismay of his village elders. He is supported by a small number of villagers and Captain Russell's sister Elizabeth (Rachel Shelley) who teaches them the rules of the game.

The colonial era is presented as unfair but not as entirely evil. The character of Elizabeth is a good, caring and understanding woman who treads between her sympathy and love for the villagers and Bhuvan, and her love for her brother. Equally, Indian society is presented as flawed and peppered with internal problems. One of the most interesting aspects of *Lagaan* is its open discussion of the caste system. Bhuvan shocks his fellow team-members when he enlists the untouchable, Kachra. Bhuvan offers a response aimed at his fellow team members and the villagers who have gathered to watch, as well as the audience in the cinema. He points out the cruelty and inhumanness of the caste system and he justifies his opinion by referencing a scene in the *Ramayana* where the god Rama happily eats the half-eaten berries offered to him by an untouchable tribal woman.

The caste system is just one way in which the film integrates religion into the narrative. Bhuvan gains his first recruit when a ball he whacks hits and rings the bell of the village's Hindu temple. The ringing – normally undertaken when a devotee approaches to pray – is seen as a divine intervention, a rallying call from the gods. Several scenes of worship and festivities take place in the temple. Religion is transposed upon Western

objects when the villagers break a coconut on a bat before its use – a tra-
ditional Hindu ritual to bless new objects and endeavours. Religion is also
transposed upon the figure of the foreign woman when a villager compares
Elizabeth's unspoken love for Bhuvan to that of the mortal Radha for the
divine Krishna. It is a love which is pure but socially impossible.

Notes

1 See http://www.altlawforum.org/PUBLICATIONS/working%20Notes/
 censorship; accessed 11 April 2009.
2 See also Rajadhyaksha & Willemen 1999: 209. For further discussions
 of Gandhi and Tagore's differing views on modernity and technology
 see Ahluwalia 1981.
3 One important development during the war years was the establish-
 ment of Rajkamal Kalamandir in 1941. The studio was established by R.
 V. Shantaram who had previously worked for Prabhat Studios in Pune,
 producer of a string of highly successful films including the Devotional
 film *Sant Tukaram*, an award winner at the Venice Film Festival in 1937.
4 On the end of this is the exhibition sector which has been another
 source of distress for the industry according to Prasad creating a
 monopoly on the market and demanding illegal payments for screen-
 ing with little government intervention (1998: 41–2).
5 An exception is the actress Tuntun, who was also known for her comic
 cameos.
6 My thanks to Akshaye Widhwani at Yash Raj Films for discussing this
 issue with me.
7 The film's follow up *Lage Raho Munna Bhai* (Rajkumar Hirani, 2006)
 sees Munna trying to pass as a history professor specialising in the life
 of Gandhi to meet a radio DJ. It is during his efforts to swot up on his
 fake career that Munna is visited by the spirit of Gandhi who tells him
 that Indians need to relearn the practices of speaking the truth and non-
 violence which is adopted by Munna under the ideology of 'Gandhigiri'.
 The film was so successful that it was commended by Prime Minister
 Manmohan Singh and even showed at the United Nations.
8 This is listed on the official website for the film: http://www.yashra-
 jfilms.com/Movies/MovieIndividual.aspx?MovieID=07bcecd7-13fe-
 413e-8a4f-6b79a9dccb40 (last accessed 11 April 2009).

2 NARRATIVE AND GENRES

Melodrama

Bollywood films may broadly be described as musical melodramas. Their melodramatic framework is constructed of oppositional binaries, highly emotional scenes and matter-of-fact dialogue executed with what might be seen as 'over-the-top' acting. The narrative is interspersed with songs that often break from the regular story and may contain fantastic elements, including changes of locations and costume. This is often done to represent the protagonist's inner-feelings and simultaneously provide a multitude of attractions for the audience. A subplot will be integrated, usually to provide moments of comic relief. The result is a narrative that strays away from the linear storytelling in real-time seen in Hollywood films. Instead there is an episodic structure akin to pre-cinematic traditions such as opera.

Peter Brooks' *The Melodramatic Imagination* (1976) is used as basis for scholarship on Western melodrama. He regards melodrama as a site for negotiating moral struggle in a modern world where religion has been pushed to the peripheries of society. This theory is difficult to apply to Bollywood. A distinctive feature of Indian modernity is found in its continued integration of religion and religious practice despite rapid technological, social and economic change. The religious and the modern are not seen as separate entities but aspects of life that are continually in negotiation with each other and often in allegiance. A harbinger for this was seen through the use of new technologies of printing which popularised 'calendar art' that became assimilated as objects of worship during the

late nineteenth and early twentieth centuries. Today, religious images and practices continue to be proliferated through equally popular and accessible forms of consumption and technology: children read comic books that tell the tales of gods and goddesses, mobile phones have religious ringtones and websites offer the opportunity for online worship. Any visitor in India today will see factories and high-tech businesses named after gods or spiritual figures and it is not difficult to witness religious ceremonies undertaken to bless new buildings or forms of modern technology such as motor vehicles. Objects of religious worship are almost always found in offices, on roadsides and the dashboards of taxis and rickshaws. Within the cinema industry, company logos and trailers often use religious symbols – such as Saraswati, the goddess of the arts (Rajshri Films) or a pair of headphones mounted on the Hindu religious symbol 'Aum' (Mukta Arts). Popular religious practices amongst Bollywood producers have included the use of specific letters for the titles of films and the use of numerology and astrology to find auspicious dates for starting production as well as setting a date for the film's release. Religious ceremonies are also undertaken before filming begins and this may include the performance of a candle-lit worship (*aarti*) or the ritual breaking of a coconut in front of the camera (see Ganti 2004: 70).[1] These practices are not just undertaken by Hindus but also those of other faiths too as specific communities negotiate their own particular relationship to India's modernisation.

Narrative and Dialogue

There are several narrative trends which have been popular in the cinema. The 'lost and found' narrative follows the Shakespearean pattern of siblings being separated from one another due to circumstances beyond their control. As they grow up their lives cross paths and slowly their true identity is revealed leading to a dénouement where the entire family is brought together, often with the addition of daughters-in-law. This ensures the continuation of traditional family life and bloodlines. The 'love triangle' mainly involves two men and a woman, as in *Sangam* with the reverse situation having been explored in *Silsila* (Yash Chopra, 1981). Other common narrative conventions include the 'good' versus 'bad' son, and parent(s) lost in childhood. The subplots of films usually involve comic characters, often middle-aged men and women or odd-looking couples. As well as

providing moments of light relief, the characters will also be involved as a sidekick to help the protagonist's progression.

It is often said that successful Bollywood films contain a perfect 'Masala Mix', in other words a recipe for success which includes certain types of characters, a certain number of songs and certain features: romantic dream sequence, fight scene, comedy moments, a happy ending. In actuality it is difficult to apply this formula to even a small number of films. All Bollywood films have specific placements, subjects and histrionics. The Masala Mix theory also fails to consider the discriminatory power of the audience, which is highly discerning, evidenced by the fact that out of the hundreds of films released every year, only a tiny number achieve box-office success. As we will see, some of the most successful movies from both past and present have controversial plots. This proves that there is a willingness on the part of audiences to witness and negotiate differing desires that may challenge culturally embedded moralities and ideals. These range from the traditional to the radical.

Bollywood films largely use Hindustani: a combination of Hindi and Urdu widely understood throughout north India. The type of language used may also shift depending on a character's religion and the geographical placing of the story. The specific use of Hindi/Urdu has shifted through time with the films produced in the pre-independence era having a leaning towards Urdu and those of the post independence era leaning towards Hindi (see Dwyer 2000a: 109). The demise of Urdu has mainly affected the song lyric. Urdu lyric traditions were held in high esteem both in romantic poetry and also in the works of Sufi performance and literary traditions. During the first years of sound film, Urdu poets, lyricists and writers flooded into the industry (for an in-depth discussion of Urdu and the cinema see Dwyer 2006a: 101–10). The use of Urdu has gradually declined since independence with the language being equated with Pakistan. Regrettably, the metaphorically intricate and coded ways of expressing love met their nemesis in the increasing use of English in the love song, most blatantly in the reoccuring use of the line, 'I love you'.

Bollywood's use of English is fascinating. English sentences are often used by Christian characters or by members of the Diaspora. The use of singular English words has often been used by upper-class characters to signal an English education or schooling abroad and this often comes across in the terminology that is used to address their parents ('mummy'

and 'daddy'). Interestingly, the words for grandparents always remain Indian. English is also used to express extreme emotions, for example feelings of anger and love. Authoritarian figures such as father figures may use terms of chastisement such as 'You bloody fool!', 'I will not allow it' and 'Get out, I said get out!' Vamps may often use the terms such as 'how dare you' and 'damn it!' These uses escalate the melodrama of the situation, as the characters' frustration is highlighted by the fact that they cannot find words to express their feelings in their own language.

What most first-time viewers of Bollywood notice is that the climactic mention of 'I love you' is the commonest English sentence used in the films. Rachel Dwyer notes that the use of English terminology here may be due either to an influence of the English language, particularly as a 'global language' and also that the declaration may be 'less intimate' when said in English following the 'prohibition of the display of the private' (2000a: 112). The use of the line also suggests a certain class, lifestyle and freedom away from traditional familial and social structures. This is particularly important in a society where arranged marriages are still the norm and where older generations and those with more traditional values view the duty of getting married as having a higher moral jurisdiction than love. Indeed, love is often regarded as something which will come and grow after the marriage has taken place.

CASE STUDY: Amar Akbar Anthony (Manmohan Desai, 1977) / *Sholay* (Ramesh Sippy, 1975)

Manmohan Desai is renowned as the 'King of Masala'. He is the one director whose films successfully follow a formulaic narrative and structure which includes something for everyone in the audience. This includes songs, romance, religion, as well as tragedy and comedy. Fate plays a hugely important role, working to reunite characters and establish order, therefore promising a victorious ending. His most successful film was *Amar Akbar Anthony*.

A string of unfortunate events instigated by a gangster leads to the separation of Kishanlal (Pran) and his family. His wife (Nirupa Roy) is struck down by a falling branch and is blinded. Their three young sons are brought up in separate households each with different religions. The Hindu Amar (Vinod Khanna) grows up to become a policeman and dates Laxmi (Shabana Azmi); the Muslim Akbar (Rishi Kapoor) becomes a singer

and dates Salma (Neetu Singh); the Christian Anthony (Amitabh Bachchan) becomes a lovable vagabond and dates Jenny (Parveen Babi). As adults the brothers – with no knowledge of their blood ties – get to know each other and their mother. The story follows in the tradition of the 'lost and found' narrative, the initial separation being resolved by the end of the film.

The film starts as a tragedy but then draws in influences from other genres and includes slapstick, play-acting, role reversal, as well as tear-jerking events, love songs, religious miracles and fight scenes. Desai is able to successfully include all these elements due to a strong overriding purpose: the celebration of the Indian institution of the family. Tradition and values are seen as belonging to any good Indian, regardless of their religion. Therefore the film's definition of 'Indian-ness' is in harmony with the secular modern state. It is the working class – the masses – who are seen as the protectors of these values. They are the 'goodies' who fight against the 'baddies': wealthy and corrupt individuals who place their personal and business interests above those of the family, community and state. By putting the family through a series of unfortunate events but bringing them together again, Desai offers the audience a sense of security and pride in their value system: it survives and adapts despite being continually exposed to external and sometimes internal pressures.

Sholay blends many aspects of the Hollywood western (violence, outlaws and territories overrun with bandits) with key components of the Bollywood film including song, dance and comedy moments. The film tells the story of Jai (Amitabh Bachchan) and Veeru (Dharmendra), who are released from prison and hired by Baldev Singh (Sanjeev Kumar) to help him avenge the murder of his family by Gabbar Singh (Amjad Khan), the most celebrated villain in Bollywood. There seems to be no reasoning behind Gabbar's actions or cause for his demise into criminal activity, something that is often shown with *dacoit* (bandit) characters. He simply enjoys being evil. *Sholay* is best known for its dialogue, and in particular Gabbar's. The dialogue was written by Salim Khan and Javed Akhtar (popularly known as Salim-Javed), widely recognised as the greatest writers in the industry. Gabbar's cursing, instructions and mottos are now part of popular culture. They are easily recalled by most film fans and are widely available: circulated on the internet and available as audio recordings.

Gabbar's first appearance is one of the most memorable scenes of Bollywood cinema and deserves special attention. The first image we see

The iconic villain Gabbar Singh (Amjad Khan) dominates the cover of the DVD release of *Sholay* by Eros Entertainment. © Sippy Films

of him are his boots and a belt of bullets he is brandishing, as he stomps across rocks. Throughout this scene, the camera always retains a sense of distance from Gabbar – It never goes in closer than a medium-shot and it even seems to creep back and away from him. This enhances the general sense of dread and fear he exudes. At the beginning of the scene, Gabbar berates three failed henchman in a voice heard off-camera. The drawn-out and fetishistic introduction heightens the impact when we first see his face. This is further exaggerated as his voice immediately changes from calm, cool and collected to outright anger as he calls his henchmen 'Suaar ki bhache!' ('Sons of pigs!'). Gabbar threatens to shoot the three men by playing Russian Roulette. Neither man receives the bullet and Gabbar breaks into laughter. Those around him slowly and nervously join in. Contrasting with the curt and direct language heard before, the laughter carries on for a significant length of time before Gabbar finally shoots the three men. The sound of the firing bullets is not followed by a crescendo of melodramatic music that might be expected. Instead all we here are the echo of the bullets and the eerie noise of crows flapping and calling. This enhances the effect of Gabbar's short, curt and matter of fact dialogue, especially at the end of the scene where he instructs his men to understand that 'the man who lives in fear is already dead'.

Music and Song

Music is arguably the most important element of Bollywood movies. Film music varies widely and contains both Indian and external influences

including Mediterranean folk (suggested by guitars), French Chanson, the Arabesque, 1980s rock and most recently Euro-dance. Music is given heavy investment from film producers and even film posters tend to highlight the composer of the music, emphasising its importance. Audiences may judge a forthcoming film as a potential success or failure depending on their personal like or dislike of the soundtrack. Songs from forthcoming films are distributed weeks before the picture's release both in audio and audio-visual format to radio and television. When songs are released on television they are usually re-edited from their original form and contain other visually exciting highlights from the film. These particular presentations may be suggestive of the genre, style and mood of a film and also showcase the stars – the other major box-office puller. Another trend has been to produce videos that inter-cut the playback singer recording the track or appearing as a performer making the promo more akin to a Western pop video.

There have been a number of hugely successful composers and it is impossible to do them all justice here. However, it is worth mentioning a few: Naushad Ali, R. D. Burman and A. R. Rehman. Naushad's music dominated the cinema of the 1950s and the early 1960s. Most of his compositions were based on Indian folk and classical music. He used both Indian and Western instruments in his music including full orchestras. His music is particularly noticeable for its use of high-pitched violins during dramatic climaxes reminiscent of the heyday of Hollywood melodrama. In contrast, R. D. Burman's music was heavily influenced by Western rock 'n' roll and has attained a cult status both in India and beyond. His songs were often sung by Asha Bhosle (the sister of India's most famous playback singer Lata Mangeshkar), whom he later married. These collaborations were to epitomise the sound of the 1970s with mega-hit songs that were often highly controversial. These included 'Dum Maro Dum' ('Take another toke') from the film Hare Rama Hare Krishna (Dev Anand, 1971), set in the world of hippy travellers in Nepal. Burman also introduced electrical instruments in his production, including electric guitars and whirring hammond organs and synthethizers, that immediately suggest the modern. Burman's use of instrumentation in his music was often very suggestive. In Caravan (Nasir Hussain, 1971), a single saxophone is played to suggest a decadent and free eroticism exemplified in Helen's alcohol-induced cabaret performance.

A. R. Rehman is the most popular composer of Bollywood film music today. He is probably best known outside of India for penning the sound-

track of *Slumdog Millionaire* (Danny Boyle, 2008) for which he won an Academy Award in 2009. His hugely successful work blends Indian classical and folk with Western influences, both old and new. Rehman began working in the Tamil cinema composing music for *Roja* (Mani Ratnam, 1992) and later *Bombay* (1995) which told the story of a Hindu husband and his Muslim wife during the city's 1992–93 inter-faith riots. Both of these films were translated into Hindi and became two of the super hits of the 1990s and also had significant exposure both at home and abroad. Rehman has a unique ability to capture and present emotions without ascending into the high pitches and meters of much Bollywood music and this may, to some extent, explain the wider accessibility to his music by the West.

For many years actors also sung songs in their films, but this changed with the advent of the playback singer. Changes in technology in the 1950s allowed songs to be recorded separately on disc and then recorded onto the soundtrack. There was no need for the actual singer to sing during the film; instead the star could memorise the song and mime, placing greater emphasis on the spectacle of dance and movement. This new technology also gave birth to a new type of star, the playback singer. The most famous is Lata Mangeshkar who has recorded thousands of songs in various Indian languages over a career that has spanned over sixty years from the 1940s until today. Known as 'The Nightingale of India', Mangeshkar's career provides an interesting insight into the phenomenon of the playback singer: certain singers have traditionally sung certain types of songs. Mangeshkar has sung romantic, ceremonial and religious songs (*bhajans*). She is associated with the composers Naushad and S. D. Burman (the father of the aforementioned R. D. Burman) whose work is associated with traditionalism and 'Indian-ness'. The connection of her name to a more authentic 'Indian' sound has been heightened by her move into singing religious songs and her status as an internationally recognised national icon who has recorded the national anthem on several occasions.

While Mangeshkar's voice is regarded as ultra-feminine and technically superior, having the ability to reach a high pitch and sing in a vast number of languages, dialects and accents, other female singing stars have also stood out. Shamshad Begum sang with a deeper voice and at a lower pitch for characters with more feisty appeal and a less soft-spoken voice. This again suggests that there is conscious choice here to choose certain singers not only for certain songs but also for certain character types.

Geeta Dutt was the wife of Guru Dutt and largely sang for the heroines in his films. Her voice was sultrier than the others, often recognisable by a slightly erotic quality felt through a distinctive quivering in the voice as heard in the song '*Na Jao Saiyan Chuda Ke Baiyan*' ('Don't let go of my wrist my love') from *Sahib Bibi Aur Ghulam* (Abrar Alvi, 1962) sung by a devout Hindu woman who has made herself drunk in an attempt to both eroticise herself and ultimately tempt her philandering husband to stay with her and not visit prostitutes. Famous male singers have included Mohammed Rafi, Mukesh and Kishore Kumar, their work largely undertaken during the 1950s to 1970s. Rafi was a universal singer whilst Mukesh was known for his mastery of melancholy and Kishore Kumar for his romantic numbers such as those in the film *Aradhana*.

The lyrics of films vary from intricately written love poems to nonsense medleys. As mentioned above, many of the early writers of song lyrics were poets from Urdu poetry traditions; the themes they wrote about often focused on the sadness of love. One of the most famous lyricists to emerge from this tradition was Shakeel Badayuni, who often wrote the lyrics for songs composed by Naushad. Terms that suggest English but are not actual words in English are used in romantic songs to create a sense of love and fun in the romantic song. Backing singers are frequently heard breaking into 'la la la's' as heroines dance or run in slow-motion across the screen. The use of English in dance songs has become increasingly popular often showing familiarity with the use of English in Euro-dance or Euro-Pop with words such as 'baby', 'party', 'dance' and 'romance'. Recent trends to use raps as bridges in songs have brought in another form of Afro-American English, or at least attempts to copy its style. Many critics and fans of the popular cinema lament that song lyrics have lost their poetic appeal. One reason for this view may be the change in language away from the traditional elements, themes and characters of Urdu poetry to less metaphorical lyrics which have increasingly used English words such as 'love', which negates the need for the rich and elaborate evocation of the feelings inspired by being in love.

The performance of a film song has huge economic value. Whilst these sequences may take place in a single fantastic setting, the use of a multitude of locations, costumes and props is overwhelmingly attractive to directors in order to surpass what has been achieved before, in the hope that the audience will be bewitched by the 'wow factor'. If the overall film

can be seen as a cinema of attractions, the dream sequences themselves can also be seen as moments of multiple attractions. For audiences these scenes are much more of an attraction than a distraction despite their frequently incongruent relationships to the linearity of the narrative.

The meaning of the film song can be both direct and metaphorical. Songs are used by individuals, lovers or groups to express their feelings; they also have a narrative role marking the passing of time often represented through the occurrence of a song which marks a religious festival or specific season such as the monsoon. Most often the song represents love in all its forms, but one situation that stands stands out is love in separation. During these songs two lovers may be singing while separate from each other but at moments they may be united together in a dream world where the lover appears as if a phantasmagoria.

The 'dream sequence' is a liminal space where the erotic fantasies of both the characters and the audience are displaced and presented through a meticulously imagined *mise-en-scène*. There may be a shift in the audience's attention away from the emotional concerns of the family and its social bonds to a personalised space allowing erotic presentations of the female body, often fragmented by the use of big close-ups of the face (eyes and lips) and fetishistic shots of erogenous zones (breasts and hips). Therefore the film song also allows for romantic and erotic transgression outside of the boundaries of regulated society for both the male protagonists and the males in the audience. To appropriate Geoffrey Nowell-Smith's term, the film song is used to 'siphon off' excess: 'in the melodrama, where there is always material which cannot be expressed in discourse or in the actions of the characters furthering the designs of the plot, a conversion can take place into the body of the text' (2002: 73).

The display of erotic pleasure is difficult to realise within the wider narrative due to cultural and legal restrictions in regards to the representation of sex. This has allowed the cinema to develop its own unique erotic language which is drawn upon in the film song. The couple are often seen running towards each other, with women often in slow-motion emphasising her position as a focus of erotic desire often confirmed by parallel shots of the hero gazing upon her. At the summation of their run the couple usually hug due to the unwritten prohibition on kissing.

Kisses are often suggested at the end of the song when the couple disappear out of shot or behind veiling devices such as flowers. But rather

than viewing the song sequence as simply an alternative to the sex act we also need to acknowledge it as a unique signifier which is often much more romantic and/or erotic than sexually explicit and/or pornographic. Madhava Prasad notes that there was a never a written law banning kissing but that the industry's choice to refrain from the presentation of kissing was, and to a large extent still is, part of a wider 'nationalist politics of culture' where its prohibition is an effort to 'maintain the Indian-ness of Indian culture' (1998: 88). For Prasad, the kiss threatens to go beyond the erotic representation of the body as it allows the interaction of two individuals outside the constraints of traditional familial structures. He argues that this is evidenced by the censors having a differing attitude to non-Indian films where kissing scenes remain intact (see also Dwyer 2006a: 289–302)

The film song is not only an attempt to present an ideal fantasy body or world. There is also an overwhelming emphasis on the visualisation of the character's emotions through attempts to externalise their inner feelings both romantic and erotic. The settings, costumes and even chorus use colours and props that may have symbolic and metaphorical value which reflect religious beliefs and provide fantasies of consumption. One way of understanding the film song is by comparing and contrasting it to the presentation of the star in the Western music video, where concerns for a classical narrative are eschewed in favour of spectacle including, but not limited to, the erotic presentation of the star. The immediate difference between the two is that the pop video is autonomous whilst the Bollywood song remains embedded within the wider film structure. But despite this difference, the two share a multitude of similarities which are played through the star's body. Pop stars are often presented singing in scenarios that have no connection to the subject matter expressed – they dwell in fantasy spaces whose changes coincide with changes in costume, make-up and hairstyles. These presentations provide fantasies of the star's lifestyle and often involve the position of the star as an almost fascist figure, surrounded by troops of dancers and followers. Some may argue that the parallel fails to hold up as what makes the pop video a legitimate work, despite its avant-garde appearance, is that it retains a sense of realism. This is not only achieved through the star's appearance, but also through the star's voice. This legitimacy collapses in the Bollywood song because of the fact that the star has never sung the song. However, the

fact that the audience accepts this as an established and expected part of the star's persona possibly suggests a differing perception of the star body and its capabilities. An actor's ability to portray the emotional angst felt in the singer's voice is a barometer of their dramatic skill. What may be seen as a dupe is, in fact, an accepted device and the audience can find legitimate pleasure in the synthesis of body and voice to create 'perfect' character types such as the ideal hero or romantic heroine.

CASE STUDY: *Baiju Bawra* (Vijay Bhatt, 1952) / *Dil Se* (Mani Ratnam, 1998)

Baiju Bawra is a period drama that tells the story of the legendary singer Baiju Bawra who lived in India during the reign of Emperor Akbar. Tansen is the court musician who requires absolute silence to create new compositions. During scuffles to maintain this silence, a religious singer is killed and he vows revenge on Tansen. A middle-aged man who adopts him and encourages him to focus his energy towards music. Baiju (Bharat Bhushan) grows up and falls in love with Gauri (Meena Kumari) but never loses his drive for revenge, which ultimately leads to tragic consequences.

The film's music was composed by Naushad and reflects his knowledge of India's classical and folk transitions. The film's intention to celebrate classical, folk and religious Indian music provides a context for highly imaginative and magical scenes. These illuminate the cultural value of the music which appears to be endowed with a mystical quality that can melt hearts and – in the narrative – stone. One of these magical moments occurs when Baiju attempts to murder Tansen. As Tansen sings each note his voice seems to illuminate beautiful frescoes on the surrounding walls in his chamber. Baiju, hidden in the shadows, is overcome by the beauty around him and is only able to strike Tansen's sitar. The subsequent reverberating sound is intensified by a shaking of the camera that desperately tries to remain focused on the frescoes.

A large part of Baiju's training is spent learning various ragas: classical Indian melodies that celebrate moods and events ranging from the meeting of lovers to the coming of the monsoon. Again, there is a mystical value attributed to music when an exquisite series of tableau's show Baiju and Gauri as personifications and allegories of various ragas. The highlight of the film is melodic duel between Baiju and Tansen where music has limitless power. The two competitors try to outperform each other by playing

classical ragas that have magical powers including a raga to light lamps, a raga to lure forest deer to the musician's quarters and, the *piece de resistance*, a raga to melt stone into water.

One of the film's most memorable songs is the *bhajan* '*Man Tarpat Hari Darshan*' ('My mind desires to have an audience with the Lord') which provides a change to the classical music evoked through much of the film. During the song, Baiju stands near a shrine to the god Krishna in the courtyard of his guru, who is sick in bed. The song has a double meaning as he is not only seeking '*darshan*' with god but he is also seeking *darshan* with his guru. As the song builds up, Baiju is joined by other singers. The camera cuts between shots of Baiju and the *mandali* to shots of the guru listening and emerging from his sick bed to shots of the shrine. At the climax of the song Baiju has *darshan* of his guru who in turn has *darshan* with God. The audience is also allowed to have *darshan* as the camera cranes down to the shrine resting on the statue of Krishna playing the flute – an instrument that is also heard at the end of the song.

Dil Se brought together a number of south Indian talents who have now become synonymous with Bollywood, including the director Mani Ratnam, producer Ram Gopal Varma, cinematographer Santosh Shivan and composer A. R. Rahman. Amar (Shah Rukh Khan) is a journalist reporting on political insurgency in India's northeastern territory. He meets and falls in love with Meghna (Manish Koirala) who is secretly involved in terrorist activities and planning to attack celebrations marking India's fiftieth anniversary of independence in New Delhi. Despite several encounters, Meghna keeps her distance. Amar is beaten by members of Meghna's group and he returns to Delhi where he eventually seems settled in a relationship with Preeti (Preity Zinta). However, his path crosses with Meghna, who is in Delhi to complete her deadly mission leading to a strange and unsettling ending.

Ratnam successfully includes some spectacular song and dance sequences. The opening number '*Chaiyya Chaiyya*' ('Shadows') is performed on top of a steam train winding its way through the Himalayan mists. The spectacle of the lead singers, including Shah Rukh Khan, dancing astride the train is added to by troupes of accompanying dancers and its effect is one of death-defying spectacle, especially in a long shot of the train passing across a bridge. Two of the other songs in the film provide a change from the Himalayas. In '*Satrangi Re*' ('So many colours') the narra-

tive is completely displaced into the world of the Arabesque with Meghna appearing as a temptress in a desert clime changing her clothes in each chorus and verse until the two are wrapped in a sheet of red fabric cavorting and striking poses. *'Jiya Jale Jaan Jale'* ('Let life and spirit burn'), a romantic song featuring Amar and Preeti, is split between the formal wedding preparations in the bridal home with fantastically erotic scenes set amidst the lush tropical backwaters of Kerala. These scenes seem to represent the two sides of marriage: the familial and social aspects contrasted with the personal and sexual. The latter is particularly suggested through the setting of the couple's dance in an exotic, rural and water-filled environment as well as their clothing, which seems to be from another time and exposes their wet and shiny skin. The upbeat love song *'Dil Se Re'* ('From the heart') juxtaposes fantasy romance scenes between Amar and Meghna with terrorist atrocities such as indescriminate explosions. Here, the extremities of love – including the decision to die for love – are shown through the device of terrorism creating a surreal ambience that links romance to death.

Genres

Rosie Thomas has defined various ways in which Bollywood forges a sense of national identity and one of these is by placing narratives in a 'ideal moral universe' where tradition both battles with and triumphs over the modern (1995: 159–60). The continued use of this setting is because of the industry's belief that audiences expect films to function within certain moral parameters. As all Bollywood cinema functions in a melodramatic framework, its films are more difficult to define into genre categories as understood in the West.

The differentiation of the industry's output into its own genre categories allows us to see its diversity, recognise the continuation of narrative, character and stylistic trends and open up considerations of authorship. It also provides a framework for studying the way in which the cinema has reflected and adapted to historical, technological and economic shifts. Below I define some of the major genres of Bollywood cinema. This is in no way an exhaustive list but will provide the reader with an insight into the variety of films produced. I have not included the Devotional and the Stunt film here as they are discussed in chapter one and have largely faded from existence.

Prasad's (1998) examination of the Social film suggests it is a site for the negotiation of ideology where traditional values become institutionalised on the screen, therefore promising revenue under highly dubious economic circumstances. He defines the Social as a 'super-genre' which establishes itself both *externally* by pushing other genres outside of the mainstream and rendering them obsolete, and then *internally* by appropriating elements of these genres into the super-genre (Prasad 1998: 46–7). The Social can therefore be seen as perpetuating and maintaining a continuation of traditional values despite social changes. Bollywood is often called an 'escapist form' and this is due to its indulgence in exaggeration and excess often through the use of opposition. In his work on melodrama, Ravi Vasudevan notes that there are often 'characteristic oppositions' at play which include 'good and evil, country and city, Indian and Western, purity and sexuality, duty and desire' and therefore the narrative functions to create a sense of harmony following any frictions caused by these polarisations (1989: 38–9). While the narrative may allow for a taste of the taboo, the Social will ultimately end with a reconstitution of the dualities through a 'cleansing, reaffirming moral conclusion' (1989: 40). Therefore, the appeal of the Social to audiences is in its role as a mirror that reflects rapid socio-cultural changes. But there is a risk that all films might be seen as Social films because by the very nature of melodrama, the narratives deal with changes forced on the family by external events. To remove this risk it is essential to define and examine other genres.

Romance is an integral part of most narratives, if not in the main plot then at least in the subplot. However, there are particular films which can be classed as belonging to a romantic genre. Romance disrupts the emphasis on family life as non-familial love is often a cause of tension between the individual and their family and even wider society, such as the extended family or village who disapproves of the romance or the couple's behaviour. Yash Chopra is considered to be the 'King of Romance' (see Dwyer 2002). His films have dealt with both the joy and pain of love, particularly in taboo, forbidden or illicit relationships. Chopra has evolved a particular style of representing romance which he has termed 'glamorous realism'. It can be defined as fantasy that is not otherworldly but more an amalgamation of capitalist desires taken to extremes. Characters dwell in flawless locations including including homes and holiday retreats embellished with consumer goods and beautiful clothes and jewels.

CASE STUDY: Naya Daur (B. R. Chopra, 1957) / *Veer-Zaara* (Yash Chopra, 2004)

Set in the world of post-independence India, *Naya Daur* tracks the effects of modern technologies on India's rural communities. Company bosses install machines in their sawmill leading to numerous job losses. They also threaten to introduce buses that will put the local horse and cart drivers (*tangawallahs*) out of business. The company bosses state that if a *tangawallah* can beat a bus in a race then the bus service will not be installed. Shankar (Dilip Kumar) agrees to the challenge. Whilst the climax of the story is the race, the film is also important due to its ambivalent attitude towards technology which was at odds with government policy of the period. Jawaharlal Nehru, the first Prime Minister of India, instigated a series of huge technological programmes which involved the mechanisation of farming, the building of infrastructure such as roads and in particular, a massive programme to construct dams. Industrialisation was to bring hope to India's population. Contradicting this, *Naya Daur* sees technology as a threat to traditional and rural life. This comes across strongly at the opening of the film where two quotes from Gandhi are displayed, stressing the importance of human labour against the foreign influence of technology. The importance of human and community spirit are exemplified in the visuals accompanying the song '*Sathi Haath Badhana Saathi Re*' ('Friends, join hands'). The song opens with an iconic low-angle shot of a silhouetted Shankar carrying an axe ready for labour, an image reminiscent of Communist propaganda images. Troops of singing workers are inter-cut with shots of marching men carrying traditional tools and women carrying basins of earth. A sense of nationalism is created through the music and visuals, again echoing allegorical monuments from the Soviet Union.

Veer-Zaara deals with the taboo love between a Hindu member of the Indian airforce called Veer (Shah Rukh Khan) and a Muslim Pakistani girl called Zaara (Preity Zinta) who meet when Zaara travels to India to scatter the ashes of her Sikh governess. On her return to Pakistan, Zaara finds that her family has finalised plans for her marriage but she realises she is in love with Veer and confides in her friend Shabbo (Divya Dutta), who arranges for Veer to come to Pakistan. Zaara's father is overwhelmed by his daughter's betrayal of traditional convention and her mother convinces

Veer to return to India to save her family's honour. Out of revenge, the estranged fiancé has Veer falsely imprisoned. It is only after 21 years that the truth is brought to light by the efforts of a Pakistani human rights lawyer (played by Rani Mukherji).

Much of the story is told in flashback as Veer narrates the story to his lawyer from his prison cell. This narrative device creates a huge sense of helpless distanciation and the tragedy of love lost which is heightened by song numbers that contain many of Chopra's reoccurring motifs, including mountainous landscapes, idylls of rural Punjab and the appearance of rain during intensely romantic moments. However, unlike many of his previous films where love is unable to thrive, the lovers are reunited. This moment replays a song from earlier in the film where Zaara could only see Veer as a phantasmagoria. Now memory and reality come into play as the camera repeatedly circles the couple, their faces changing between their younger and current appearance with each rotation.

This is a romance with a political agenda and the presentation of two hearts that do not recognise borders allows clarity in its presentation of Pakistan. One of the themes of the movie is the shared heritage of the Punjabi people. During partition, the Punjab was literally sliced in half between India and Pakistan. The film suggests that the cultural identity of the Punjabi people is not influenced by political borders and this is explored in the song 'Aisa Des Hai' ('My country is beautiful') in which Veer shows and describes India to Zaara who replies by singing of the similarities of her country including its people.

The Historical and the Islamicate Film

During the sixty years since independence Bollywood has played a crucial role in defining the nation and its peoples, from ideas of national identity to questions of individual social and moral conduct. The presentation of history plays a key role here raising questions both about Indian identity and the way in which filmmakers decide to depict the past, the accuracy of historical facts (figures and events), issues of authenticity (details of sets and costume) and contemporary resonance (social, religious, political) of past figures and events.

There are particular periods that deserve focus when discussing historical films including Partition and the Mughal period. The Partition of India

is a living memory for millions of Indians and its discussion, let alone representation, is still sensitive and can spark controversy. Whilst Indian independence is largely seen as a huge victory it is one that many consider to be bitter-sweet. An estimated million people died in the migrations and communal riots following Partition which became the largest mass migration of people in history. One of the first films to deal with the issue was Yash Chopra's *Dharamputra* (1961), produced by his elder brother B. R. Chopra and based on a book by Acharya Chatursen Shastri. The story surrounds two neighbouring families in Delhi, one Hindu and the other Muslim, whose lives are changed in the religiously fuelled violence during the lead-up to partition. The film is particularly poignant as the Chopras lived through the horrors of partition migrating from Lahore to Bombay (see Dwyer 2002: 18–20). The film is highly spirited in its representation of Hindu/Muslim unity and contains tremendous performances. But despite all of its qualities it did poorly at the box office because of its controversial and political subject matter (2002: 34–8). Today, there are increasingly mixed views towards both the leaders of the independence movement and the Muslim population that remained in India. The tensions surrounding these issues have been heightened since the 1990s with the rise of Hindu nationalism.[2]

In the post-colonial period, the highlighting of India's Islamic history was crucial for various reasons. Primarily, the projection of an idealised secular past could show how religious harmony is possible in India. The cinema seemed to have a vested interest in presenting historic figures who had governed society justly and morally without forcing their particular religious inclinations. This is particularly poignant for an industry which, as we have seen, has always had a mix of communities amidst its workforce. There have been many films which have been set in exclusively Muslim worlds although not necessarily dealing with the issue of religion and this is the reason why Dwyer (2006a: 97) categorises these films as Islamicate rather than Islamic. She defines several sub-genres of the Islamicate film including the Muslim Social, Fantasy Film, Courtesan Film and Historical. Iqbal Masud has further defined historical films by calling those films set in the Mughal period 'Shahenshah films'.[3] The Muslim Social and the Courtesan film represent a specifically Indo-Islamicate world and they have also proved to be some of the most memorable works of cinema, raising issues of national memory and recuperation as well as cultural fetishism and curiosity.

Muslim Socials are set exclusively in the world of the bourgeois Muslim family, focusing more on the particulars of the artistic and cultural worlds they inhabit rather than on religion. This includes indulgence in the Urdu poetic tradition which manifests itself both in the script and in the song lyrics, and is often a major passion of one or more of the lead characters. The Courtesan film remains another important sub-genre of the Islamicate film. Traditionally these courtesans were trained in conversation, poetry, singing and the playing of instruments, and their artistic achievements were highly prized; they both embodied and preserved Indo-Islamicate culture in all its excellence.

CASE STUDY: Mughal-E-Azam (K. Asif, 1960) / *Barsaat Ki Raat* (P. L. Santoshi, 1960)

The epic historical *Mughal-E-Azam* tells the story of the legendary love affair between Prince Salim (Dilip Kumar), the son of Emperor Akbar, and the courtesan Anarkali (Madhubala). The film had achieved legendary status even before its release, not only because of the on-and-off screen romance of the leading couple but also because it took fifteen years to produce and was touted as the most expensive film in Indian history. It also brought together two of the biggest stars from the pre-Independence era, Prithviraj Kapoor in the role of Emperor Akbar and Durga Khote as his Hindu Queen, Jodhabai.

Throughout the film, history is presented as spectacle and the film delights in portraying the majesty of what it sees as India's glorious past. Costumes and jewellery were fashioned by craftsmen from all over India and the battle scenes featured battalions and cavalries of the Indian army including elephants, camels and horses and a cast of hundreds. When filming first started, the movie was shot in black and white but later two colour song sequences were added. Both of these take place within a fabulous hall of mirrors. In one of these Anarkali sings the song '*Pyaar Kiya To Darna Kiya*' ('Why should I fear if I am in love?), daring to declare her forbidden love for Prince Salim in front of the Emperor and the Queen.

The Emperor Akbar is a favourite Bollywood figure. HIs reign is often considered a golden age of religious tolerance and justice. In *Mughal-E-Azam* he is portrayed as an ideal ruler who is respectful of all religions. This is shown in the scenes when he takes part in the Hindu festival of

The courtesan Anarkali played by Madhubala, the 'Venus of India', in *Mughal-E-Azam*. © Shapoorji Pallonji

Janamashtami (the birthday of the god Krishna) and also when he is simultaneously blessed by Muslim and Hindu priests before going into battle. At several points in the film he highlights the importance of justice in Mughal rule and a recurring motif is a large pair of scales which becomes unsettled when wrongs are committed.

Revealing and veiling are key motifs in the film from the revealing of the living sculpture of Anarkali to her singing the line 'Why fear when nothing is veiled from the Almighty?' (in the aforementioned song) and her punishment of being walled up alive before having an escape route revealed to her by Akbar. In the scene where Salim and Anarkali have a secret meeting the carnal is veiled with the accoutrements of romance. The lovers are surrounded by voluptuous visuals including ornamental gardens, doves and cherry blossom canopies. Serenading sounds include running fountains, birdsong and a romantic evening raga sung by the court musician Tansen. Salim gently brushes Anarkali with a feather as she coquettishly disappears behind each stroke reflecting the rhythm of lovemaking.

The politics of veiling is strictly linked to the female body and whilst the motif can be seen in an Islamicate context there is also an erotic purpose. Anarkali is the object of various gazes: voyeuristic and romantic; familial

and public; authoritarian and active. The climax of her performance in the hall of mirrors occurs when we see her image multiplied in every single piece of decorative glass. Whilst this exposes her objectification it also highlights her knowledge of the gaze turning it back on those who gaze upon her.

The setting of *Barsaat Ki Raat* is amongst the erudite and cultured urban Muslims of pre-independence India. Little emphasis is placed on religion and instead the film focuses on capturing the lost grandeur of a gilded age. In particular, great pleasures are derived from the performances of traditional music and dance. The poet and singer Aman (Bharat Bhushan) lodges with a family of singers before moving to Hyderabad where he pursues his career and sings on radio. Shabnam (Madhubala) is one of his greatest fans and unbeknown to each other their paths cross as they seek refuge from a rainstorm. Aman writes a song describing their encounter and sings it on the radio. This scene is one of the most simple but beautiful presentations of the film song, contrasting Aman who is transfixed as he sings and Shabnam, whose joy is physical, dancing around her room and repeatedly leaning against the radio. Their romance begins but her father ends the relationship and arranges her marriage. Aman returns to the family he initially lodged with and helps them regain their position as the leading musical performers in their territory. During a series of rapturous performances the tangles of the tale are sorted and Aman and Shabnam are reunited.

A central pleasure of the film are its songs which have Islamicate influences. The song performed by Aman is in the mode of a *ghazal* – these are songs which often focus on the sadness of love (separation, despair, heartache) and their origin can be traced back to the Persian courts of the thirteenth century. The film also features several performances of *qawwali*, a form of popular devotional music performed amongst Sufi traditions in India. The form of qawwali favoured by Bollywood has been the *muqabla* (see Dwyer 2006a: 109–10). These are melodious duels sung by competing teams of singers normally around the subject of love. The competitor is usually surrounded by a group of backing singers and musicians. The musicians are then able to follow the music due to the *qawwali*'s regular rhythm marked by the beating of a drum. While a subject for the melodious debate is set, the competitors must improvise lyrics often in response to arguments or questions sung by the competing side.

Supernatural Genres

As discussed in the first chapter, the Mythological was the first genre to emerge in India. There are two forms of Mythological films: the first is set almost exclusively in the world of the gods, also known as 'Puranic' films, its name a nod to the *puranas*, a collection of religious histories, myths and legends first written down in the third-to-fifth centuries, but having a much older oral history. An interesting characteristic of the Puranic film is that whilst it centres on a key narrative it also includes references to other narratives. The story is therefore not necessarily 'to the text' and there may be chronological manoeuvres or shifts in allegiances to particular gods which betray wider popular knowledge. This artistic license allows the film-maker to illuminate further their chosen deity by concentrating on their role in popular tales. The second type of Mythological is often set in the present with interaction between the heavens and a mortal protagonist whose faith is put to the test.

The Mythological has been in decline since the 1950s and is now mainly produced in the B-movie sector.[4] This is in sharp contrast to its comparatively thriving position in India's other major cinemas, particularly in the southern states of Tamil Nadu and Andhra Pradesh where the production values of the films have always seemed to be much higher with a no-expense-spared approach to sets, costumes and CGI special effects. Regionally-produced films may also have specific references to the vernacular; for example, through the use of local deities and the inclusion of folktales and songs. However, they may also attempt to heighten the cultural value of a specific region. A vivid example of this is in the Tamil film *Saraswathi Sabatham* (A. P. Nagarajan, 1966). Throughout the film, references are made to the glory of the Tamil language. This is most evident when Saraswati (the goddess of language and the arts) grants the power of speech to a deaf devotee who then bursts into song and sings her praises as Tamil letters emerge from a statue of the goddesses.

Dwyer explains that audiences have largely been derogatory in their view of the Mythological (2006a: 54–7). The movies are often filmed on unconvincing studio sets which expose the lack of financial investment in the film. Despite the fact that many of these films are based on the epics, it is continually surprising how supposedly huge battle scenes are scaled down and attempts are made to hide this through the repetition of shots

(often of flying weapons) to stretch the scene. The extra heads and arms of various gods and goddesses are often made out of hard-board or papier-maché and appear one-dimensional. Gods may be shown travelling on their animal vehicles which face sideways but they sit on the side of the mount facing the audience. The awkwardness of the effect is exaggerated by the immobile plasticity of the animal vehicle which is often depicted with jaws and talons wide open as if frozen mid-attack. The saving grace of the Mythological is its relationship with its audience who will sideline such disparities in the special effects in favour of grasping the storylines, the quarrels and domestic dramas of the gods and the moral messages being conveyed. Rather than receiving a technical evaluation the special effects are accepted as symbolic representations.[5]

CASE STUDY: Jai Santoshi Maa (Vijay Sharma, 1975)

This hugely successful Mythological is barely a B-movie, using unrealistic sets and unintentionally amusing special effects. However, it is the narrative and songs that grasped and continue to grasp audiences. While the film shows the gods it presents them as mischievous, conniving and jealous beings who, quite brutally, test the devotion of Santoshi Maa's most ardent devotee, Satyavati (Kanan Kaushal), the key protagonist.

Her position as downtrodden daughter-in-law probably accounts for much of the film's appeal with the theme of the in-laws and daughter-in-law (Saas-Bahu) being a major narrative device in family dramas both in cinema and television. In particular the film focuses on the hierarchical relationship between the various daughters-in-law from whom Satyavati suffers both humiliation and domestic violence. However, her devotion to her deity does not waiver and at each family-induced or external hurdle the goddess Santoshi (plaued by Anita Guha) appears in various guises to save her devotee. This includes hurling her trident which transforms into a serpent to ward off a potential molester and transforming herself into an elderly woman who provides Satyavati with offerings for the goddess which her family have denied her.

The tales surrounding the film's screenings are legendary ranging from audience members removing their shoes outside the cinema to devotees throwing flowers at the screen during the manifestations of the goddess.

The success of the film changed Santoshi from a minor deity to a hugely popular goddess both in India and amongst the Diaspora.

One popular sub-genre of the Mythological is the Snake Film. The central protagonists of snake films are *nagin* – women who have supernatural powers that allow them to transform into snakes. These figures are traditionally considered to be divine and are found in both mainstream Hinduism, where they are associated with major Hindu deities such as Vishnu and Shiva, and also in tribal beliefs. Some snake films have become mainstream successes and have featured big-star casts. The movies have many of the features of Western horror films, including heightened suspense and numerous attempts by protagonists to avoid death by female beasts. The *nagin* is often a figure of romantic interest but also a highly erotic being in control of her own sexuality. *Nagin* (Rajkumar Kohli, 1976) tells the story of a snake-woman whose partner is killed before the sex act takes place. She spends the rest of the film avenging her partner's death. This narrative demonstrates that although she is a legitimate figure in organised religion, the *nagin* has uncontrolled animal instincts. She blends the sacred and the profane within her being and therefore defies traditional gender binaries, offering a challenge to the figure of the monstrous feminine in other cinemas.

Horror films remain at the peripheries of Bollywood, however they do enjoy a cult following both in and outside of India. Indian ideas of horror focus around the 'black arts' such as witchcraft, possession such as somnambulism and curses that are often aimed at inflicting infertility or destroying family lineages. The most successful horror directors are the Ramsay Brothers, whose hits *Purana Mandir* (1984) and *Bandh Darwaza* (1990) are cult classics that blend demons inspired by Western popular culture (such as werewolves and vampires) with the additional ability to punish their victims with curses. Both of the aforementioned films share a penchant for gratuitous shots of women that touch on the pornographic, suggesting a secondary appeal of the genre. Vijay Mishra has discussed the films *Mahal* (Kamal Amrohi, 1949) and *Madhumati* (Roy, 1958) as defining a style that he calls 'Indian Gothic' (2002: 49–59). Both of these films deal with the ghosts of women and the stories are located in isolated places.

Other Genres

Despite India's involvement in World War I and II and its four wars since independence – one with China and three with Pakistan – there have not been many movies made on the subject of war. The tension surrounding the disputed territory of Kashmir has led India to maintain a substantial military presence along the border with Pakistan. Terrorism has been a major issue in the last twenty years, not only in this area but also with Sikh militants during the 1980s, the Tamil Tigers in the 1990s and more recently Naxalite rebels in the East. India's increased military might through its emergence as a nuclear power in 1998 and the significant border disputes with Pakistan over Kashmir in 1999 have ignited interest in the war film. Perhaps the most famous comes from this period. *LOC.: Kargil* (J. P. Dutta, 2003) is a four-hour epic. As well as focusing on the front line, the film also devotes time to display the effect of the war on the soldiers' friendships and families who come from Hindu, Sikh and Muslim backgrounds. The film is an excellent example of the industry's attempts to create cinema for the global stage. Realistic battle scenes (including the use of military arsenal) and emotive scenes depicting the strength of friendship and bereavement are interspersed with conventions such as the song and dance sequence often promoting a sense of nationalism.

The gangster has always been a figure of affection and hatred in Bollywood with the character either belonging to the sophisticated urban underworld or the rurally-based *dacoit* leading a team of bandits. The gangster regularly featured in many rurally-based films of the 1950s and 1960s, including *Mother India* and *Gunga Jumna* (Nitin Bose, 1961). In both of these the heroes are forced to become *dacoits* due to familial and societal pressures, not through being inherently evil. Despite this their deviance is often punishable by death. During the 1970s, the urban gangster was a locus of visual spectacle. This was demonstrated in his fetishistic clothing, and his being surrounded by spectacular locations, such as glamorous boudoirs and glitzy nightclubs. This is seen in *Don* (Chandra Barot, 1978) whose visual spectacle is echoed in its 2006 remake by Farhan Akhtar (with the addition of a final twist to the plot). The most prolific filmmaker of gangster films is Ram Gopal Varma. His films *Satya* (1998) and *Company* (2002) are both set in the urban underworld but they are stripped of any glamorous attractions and remain embedded in gritty realism.

Notes

1 There is even a helicopter service which flies films to the shrine of Sai Baba of Shirdi, a favourite figure of devotion in the film industry and the Mumbai community who is revered by both Hindus and Muslims (see Dwyer 2006a: 94).

2 The subject of love in the face of Partition was also explored in two more recent films: *Gaddar: Ek Prem Katha* (Anil Sharma, 2001) and *Pinjar* (Chandra Prakash Dwivedi, 2003). *Gaddar* has a Sikh hero who falls in love with a Muslim girl before Partition. Their paths cross again when he is part of a mob undertaking a bloody rampage but he rescues her as she flees from attackers after surviving a massacre in a train – shown in frighteningly graphic detail – when her family flees to Pakistan. *Pinjar* has a much more complicated representation of love when a Hindu woman is kidnapped by a Muslim to avenge a long-standing feud between two families. However, here the Muslim has fallen in love with the woman and refuses to defile her. She escapes to her family but is disowned, leaving her no choice but to live her life with her abductor as wife and husband. A few years later when Partition takes place the same family must flee to India during which they experience the tragedy of their daughter-in-law's abduction and rape. This makes them reassess their attitudes but despite the willingness to accept the heroine, she stays in Pakistan with her husband.

3 See http://www.screenindia.com/fullstory.php?content_id=9980; accessed 11 April 2009.

4 For further discussions of the Mythological, see Dwyer 2006a: 12–62.

5 Hindu mythological titles from the past remain popular choices for film viewing at home with a large number of films produced between the 1950s and the 1970s enjoying circulation since the introduction of video in the 1980s and on VCD and later DVD in the 1990s.

3 CHARACTERS AND MORALITY

This chapter discusses some of the major character types that appear in Bollywood films. These characters are by no means set in stone and indeed some, like the vamp, have almost disappeared. Sometimes these characters are stereotypes and caricatures whilst at other times they are more ambiguous. Their presentation is also affected by issues of genre and the historical and social climate in which the films were produced. However, an overview of stock characters allows us to highlight various melodramatic stereotypes, cultural expectations and recurring personality traits.

The Ramayana and the Mahabharata

The two Hindu epics, the *Ramayana* and the *Mahabharata*, have had a profound effect on Bollywood. There is a general belief by the industry and viewers alike that storylines, characters and themes in films can be traced back to these texts whose characters are seen as possessing the ideals of a supposed 'Indian-ness', bequeathing moral codes of conduct to individuals, families and society, therefore providing relevance at both a grass-roots and national level.[1] This idea is given further credence by the fact that many Hindus consider these texts to be a part of India's history. Characters are often named after the heroes and heroines while generic character types are often infused with elements which link them to a specific 'good' or 'bad' individual. Unfolding dramas are often infused with

ingredients from the plots and subplots, echoing dramatic moments from the epics.

The two epics were traditionally handed down orally before being written: the *Ramayana* around the fourth century BC and the *Mahabharata* around the fourth century AD. Each has many regional and linguistic variations with the narrative and themes being exaggerated, diluted and mutated to suit particular historical and socio-cultural needs. These variations are not only seen in the profusion of written versions but also in local forms of performing arts ranging from puppet shows, songs performed by travelling religious music groups and the performance of plays during religious festivals. All of these retellings stick to the basic skeletal structures of the epics, which are full of moments of transgression, moral difficulties and internal family feuds that may cause mixed emotions in readers, listeners and viewers.

The *Ramayana* is considered central to Hinduism as well as being widely known in popular culture. An earlier adaptation of the *Ramayana* is said to be the only film seen by Mahatma Gandhi. A brief explanation of the most popular version of the narrative follows.

Following years of penance, the demon Ravana is granted powers from the god Shiva and he subsequently terrorises the world. The gods implore Vishnu to incarnate on Earth and deliver them from evil. Vishnu is born on Earth as Rama, son of King Dasharat of Ayodhya. Prince Rama grows to be a handsome and brave warrior and wins the hand of Princess Sita. However, following a series of family disputes, Rama and Sita are banished from the city of Ayodhya for fourteen years. They are joined by Rama's brother Lakshman and live in the enchanted forest Panchavati. The ogress Surphanka (sister of Ravana) makes sexual advances to Rama who rejects her. She attempts to attack Sita but has her nose and ears cut off by Lakshman. Surphanka seeks out revenge with Ravana who is now King of Lanka. Through trickery he kidnaps Sita. Rama and his brother Lakshman go in search of Sita and are assisted by the monkey-god Hanuman. Together they defeat Ravana and his army, rescue Sita and return to Ayodhya. It is this return which is celebrated in the festival of Diwali. Their period of rule is referred to as Ram Rajya: a golden age of peace, justice and prosperity.

In the *Ramayana* the king Rama and his wife Sita are considered to be ideals. This is demonstrated through their actions which see them following the correct paths of virtue and conduct in the various roles

required of them: Rama is considered the perfect king, husband, brother and friend just as Sita is considered the perfect daughter, bride and wife. The *Mahabharata* is a much more complicated and somewhat darker text which centres around a battle between rival cousins, the Kauravas and the Pandavas. The Kauravas use trickery to beat the Pandavas in a pivotal game of dice but the latter are also seen as wholly impotent as the eldest brother Yudhishtra gambles away his kingdom and finally Draupadi, the wife he shares with his four brothers. This leads to a series of humiliations culminating in the public disrobing of Draupadi. This is one of many key moments at which the god Krishna appears throughout the text. Here, he magically turns Draupadi's sari into a never-ending robe of silk which saves her from being exposed. In the war of retribution that follows, he acts as a charioteer for the Pandava Arjun and before the battle reveals the secret of divinity in both his godly form and in the revelation of a divine text called the *Bhagavad Gita* – 'The Song of God' – which imparts knowledge on the importance of the soul (*atma*) above the body and reveals its endless cycle of birth, death and rebirth until it reaches enlightenment (*moksha*). Krishna therefore helps Arjun to overcome his fears before he goes into bloody battle against his own kin so that he can perform his personal and social duty, called *dharma*, which is declared the most important of human duties, even if it causes the spilling of familial blood.

Vijay Mishra sees the narrative and ideology of Bollywood as 'homologous' with these two Sanskrit epics. He cites the reference to desire, law, order and revenge in the epics as having a significant impact on the cinema which continually refers to these through a policy of 'discursivity' whereby actions are surrounded by constant referrals to supposed spiritual truths and rules of conduct (1985: 135–7). As a result of this the cinema provides a confirmation and continuation of values and disavows any deviance from the instructions of the epics, particularly those involving the upholding of Hindu social structures. Whilst cases supporting Mishra's argument are easily found, the degree to which they can be applied varies and there are particular mechanisms at work, for example the consideration of how a particular character or a particular situation would fare in the modern world. It would also prove difficult to apply Mishra's ideas to all Bollywood genres, for example the Islamicate film which may remain exclusively in a specifically non-Hindu setting, or in narratives dealing with the Diaspora which dwell in worlds well away from India. It is also important to remember that

one of the most striking traits of the industry is its conscious decision to highlight, question and challenge social ills inherent in society. Whilst the films do not always offer a satisfactory resolution through a happy ending, they do dare to explore taboos and therefore lift a mirror to the audience forcing them to reflect on their own lives, values and opinions. These are most-often explored and played out in the context of the family, the bastion of Indian tradition and identity.

The Family

The role of the family is of paramount importance in Bollywood, as it is the locus for negotiating the friction between personal desires and religious and social obligations. Most Indian families share the ideal of habitation within the framework of the joint or extended family, although in actuality such living conditions are becoming increasingly rare, particularly in cities. This ideal family would not only include three generations but also brothers, their wives and their children. Individuals would have various duties and expectations dependent on generation, age and gender. It is this family structure that is widely celebrated in the movies as a common cultural and national representation of 'Indian-ness', crossing the social barriers of religion, caste and geographical location. At the same time, the family structures are never so rigid that they cannot negotiate or cope with change. Indeed it is not only the durability of the family institution but also its adaptability that is celebrated.

The inclusion of religious festivals and family events provides an ample opportunity for the sanctity of family life to be celebrated. In *Hum Aapke Hain Kaun...!* the events of birth and marriage are presented as communal events with members of the extended family, friends and community invited to take part in rituals. The greatest scope for presenting the joy of family is through the Hindu wedding. This event is separated into various ceremonies that stretch from the preparation of the couple at their paternal homes, through the arrival of the groom to the bride's house and her subsequent departure to her husband's home. Wedding songs are hugely popular in films and vary depending on the mood of the moment. Preparation songs are joyous and include the hit song, '*Mehendi Laga Ke Rakhna*' ('Apply the ceremonial henna to the bride's hands') from the previously mentioned *Dilwale Dulhaniya Le Jayenge*. Songs marking the

bride's departure often stick with traditional instrumentation and are mel-ancholy in tone such as *'Chorde Babul Ka Ghar'* ('Leaving father's home') from *Babul* (S. U. Sunny, 1950). Many of these songs have become part of popular culture, being played at weddings either as backing music or by big bands. They may even be added as backing tracks to home wedding videos/DVDs.

Parents

Indian societies are largely patriarchal structures with the father having precedence in the household.[2] In Bollywood, the father is often a hugely domineering influence representing tradition and its continuation. In *Kabhi Khushi Kabhie Gham...* (Karan Johar, 2001), the extreme stubbornness of the father leads to his estrangement from his eldest son. Disobeying the commands of the father may result in the child falling into disrepute as in *Andaz* (Mehboob, 1949), where Neeta (Nargis) descends into social and finally marital castigation – something that is clearly linked with her inability to follow her deceased father's guidelines on appropriate social behaviour. The father/daughter relationship seems to be particularly precious in the representation of the well-to-do family where fathers are often shown doting on their daughters showering them with blessings and gifts. These representations are also interesting as they go against many of the assumptions about the position of the daughter in Indian societies. The birth of a girl is not necessarily seen as an inauspicious or unfortunate event, but it may not arouse the same levels of excitement that the birth of a boy would bring. This is for various social and eco-nomic reasons. For example, the birth of a daughter may incur long-term expense due to the practice of dowry. In contrast, the birth of a son will bring benefits including a marriage into the family, the continuation of the family name, grandchildren in the home and, due to the desired setting of several generations living together, security, protection and comfort in old age.[3] The family with a missing father has been a common theme in Bollywood. The scenario causes the family to collapse despite all the efforts of the mother. This is often evident through the sharp contrast of a 'good' son who is a law-abiding worker and a 'bad' son who takes the law into his own hands. Interestingly, while the 'good sons' are dutiful to their mother and society, they never seem to be 'man enough', shown in

their inability to control their wayward brothers. The 'bad sons' are often shown as being essentially good at heart with the aim of restoring their own, as well as their family's self-respect and honour (particularly that of the mother). However, the path of crime they take makes them unsuitable for the domestic space. This causes both the mother and the audience to have a continually imbalanced view of the men. As the imbalance occurs due to the lack of the pivotal father figure, it can be suggested that it his very absence which highlights his importance as the traditional head of the family.

For those who are new to the cinema, the mother is often the most difficult figure to come to grips with. Out of all characters she is often an extreme ideal who has to carry out both the traditional roles of the dutiful Indian daughter-in-law, wife and mother alongside having the supposed moral superiority of a divine goddess. Indeed, it could be argued that goddesses are allowed more faults than the Bollywood mother. Rather than being extremes, goddesses are often complicated with hot and cold temperaments. Tales of the goddesses represent them as having human emotions and qualities; for example, they often squabble with their husbands and other goddesses. Further complications occur as not all goddesses belong to the traditional Hindu pantheon. There are many local goddesses who some may believe to be incarnations of traditional deities and they are often associated with nature, for example geographical features or diseases, and they may demand the performance of specific rituals to be pacified. There are also mortal women who have become deified. All in all the goddess is an unrestrained and mutable being who can be both benevolent but also horrific in her punishments. In contrast, mothers are highly idealised and often depicted as allegorical figures representing the family, Indian values and even the nation. She is loaded with significance and her ability to weather numerous storms turns her into a beacon of hope for the continuation of tradition.

Step-mother figures are often cruel and exploitative. This is seen in *Seeta aur Geeta* (Ramesh Sippy, 1972) where separated twins lead very different lives. The orphaned Seeta is brought up by her aunt who takes her inheritance and forces her into a life of slavery. Geeta grows up to be a self-assured entertainer, but fate, as always, lends a hand and the two sisters' lives are swapped, the feisty sister ensuring that the aunt receives all the retribution she deserves.

Romantic Leads

Romantic heroines are only played by the most beautiful of actresses. Particular actresses have played particular types of romantic heroines: Madhubala and Meena Kumari often playing the tragedy queens through the 1950s and 1960s, and Sri Devi playing the romantic interest in comedies and romances through the late 1980s and early 1990s. Kajol has been a favourite to play loveable and innocent characters such as the tom-boy who blossoms into a fully wholesome Indian woman in *Kuch Kuch Hota Hai* (Johar, 1998). More recently Preity Zinta has become the choice for playing the hip and trendy Indian abroad. Many of these stars have achieved superstar status amongst fans of all persuasions as well as acquiring specific titles such as Meena Kumari as 'The Tragedy Queen' and Madhubala as 'The Venus of India'.

Although she is a stock character, the romantic heroine has not remained a constant character type. Her position has become more liberal over time and a pivotal point was the 1970s. A move away from traditional romances to gritty urban films required a different type of heroine who was more physically agile and expected to take part in the action. The two iconic film stars of this period were Zeenat Aman and Parveen Babi. Both of these stars were models and this solidified a trend which carries on today of models making a natural transgression from catwalk to screen, most recently and famously through former Miss World, Aishwarya Rai.[4] In romances set in the present day, the romantic heroine often wears Western clothing but has traditional values and devotion to her family and this may sometimes be called upon to bring the romantic hero into line, suggesting that she is still entrusted with the upholding of cultural values.

The Romantic Hero

The romantic hero is a particularly complicated character. Contrary to popular opinion, Bollywood films do not always end happily and this is often due to the actions or rather inactions of the hero. The tragic romantic hero has been a reoccurring character, particularly during the 1950s and 1960s. During these periods he was often played by either Dilip Kumar or Rajendra Kumar. These characters often had a stifled masculinity. They exuded vulnerability and passivity, often breaking into tears or dying by

the end of the movie. As previously discussed, there are plenty of romantic films but not many that follow a fairytale scenario as in Western folklore or cinema, where the hero rescues the damsel and the two live happily ever after.[5] In an Indian setting this path is difficult to follow because there are different cultural conditions and responsibilities in social structures, including the tradition of arranged marriage and the importance of the family above the self. But this also provides an opportunity for a greater fluidity in the presentation of the romantic hero.

As Laura Mulvey (1975) has argued, Hollywood cinema has traditionally placed the female figure as the object of the erotic gaze with the hero being essential to the narrative drive of the film. In Bollywood the division is not so strict; romantic heroes are often placed in a position that forces them to be passive objects, subject to an erotic gaze. Romantic heroes, particularly from the later 1980s onwards, have become excessively stylised in terms of their dress, outer appearance and mannerisms. They are all young look-ing, display 'boyish' characteristics and mannerisms (perhaps part of their appeal to a family audience). They have highly stylised hair and wear what are considered to be highly fashionable clothes. On first look they are very unthreatening. But their indulgence in accessorising their appearance is counteracted by the hyper-masculinity of their muscular bodies concealed beyond their hairlines and clothes. These bodies often have to go through some sort of physical test to prove the character's worthiness. This is seen in the two Shah Rukh Khan films *Dilwale Dulhaniya Le Jayenge* and *Pardes* (Subhash Ghai, 1997) where his character crosses social boundaries by falling in love with the wrong woman. He is subsequently beaten senseless by his girlfriend's family but still manages to remain standing, allowing the family to accept him.

CASE STUDY: Hum Aapke Hain Kaun...! (Sooraj R. Barjatya, 1994) / *Mother India* (Mehboob, 1957) / *Devdas* (Bimal Roy, 1955)

Hum Aapke Hain Kaun...! is a family comedy full of stereotypical characters that are scripted to almost pantomime-like proportions. It was and contin-ues to be a hugely popular film that celebrates the Indian institution of the extended family (see Uberoi 2000). Prem's (Salman Khan) elder brother Rajesh has his marriage arranged to Pooja, the sister of Nisha (Madhuri Dixit). Prem and Nisha fall in love during a series of visits and meetings

held for the engagement and marriage ceremonies. Tragedy strikes when Pooja suddenly dies after falling down the stairs. Nisha's mother and father suggest she be married to her widowed brother-in-law. Nisha places her parents' wishes above her own desires, and agrees. Her good intentions are rewarded by divine intervention which is exercised via Tuffy the pet dog who points out to the elders that the younger couple are in love. Nisha and Prem's traditional purity is revealed to their families and they receive their blessings and are married.

Hum Aapke Hain Kaun...! demonstrates that younger generations can still maintain a sense of duty to family despite being exposed to all the trappings of modernity, including ideas of romance. The film creates somewhat of a utopia (see Inden 1999) both through the ideals of these characters but also the relationships that are represented. Family friends are treated as blood relations; this includes those of other religions who attend Hindu ceremonies, and family servants who are seen as a part of the wider extended family taking part in the planning of celebrations and having close physical and emotional relations with their employers. Many of the film's songs are now embedded in popular culture by becoming classic wedding songs played on disc or sung as part of the celebrations. Cinema's ability to embed itself in the psyche of the nation has been witnessed since Phalke's first feature film; however, no other film has had the impact of *Mother India* and much of this is due to the allegorical role of its central character.

Mother India follows the struggle of Radha (Nargis) whose family becomes increasingly indebted to the corrupt moneylender Sukhilala (Kanhaiyalal). During a desperate attempt to prepare wasteland for farming, Radha's husband Shamu (Raj Kumar) crushes his arms under a rock. Unable to support his family and publicly humiliated by the moneylender, he leaves Radha to struggle on her own for her family's survival. The film has become an epic of modern India (see Chatterjee 2002). Radha is not only a representation of the nation which provides (mothering, tending, toiling and producing), she is also the protector of the nation (upholding the honour of herself, her family and her community).

Following a flood that destroys the village, a desperate Radha visits the moneylender offering herself in exchange for food to feed her sick children. As she enters his home the moneylender calls her Laxshmi (the goddess of wealth). The names have particular connotations here: according to

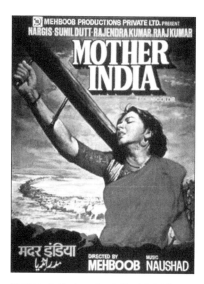

Nargis as Radha in an iconic 'Soviet style' pose on a poster for *Mother India*.
© Mehboob Productions Private Ltd

religious lore, Radha was in love with the god Krishna; however, she is married off to another. Krishna's consort is Rukmani who is an incarnation of Laxshmi. Radha the mortal stands before an idol of Laxshmi the divine, declaring that a goddess may be able to bear the weight of the universe but she could never bear the weight of motherhood. Radha symbolically removes her *mangal sutra* (a necklace worn by married Hindu women) and hurls it at the goddess. The moneylender attempts to remove the idol to prevent it from witnessing the crime, but Radha demands the idol of the goddess remain to behold her humiliation. A scuffle leads to Radha rediscovering the *mangal sutra* and she sees this as an act of divine intervention. She proclaims that the goddess will return her husband and protect her children. The moneylender attempts to rape Radha but she beats him off and pushes him into a bag of cotton (a symbolic spoiling of the debt her family owes him) before returning to her children.

During the film, Radha turns from a passive young bride to a strong single mother. It is also at this point that her mothering role encompasses the entire village. Despite the damage caused to the land by the flood she convinces her fellow villagers to stay and restore the village to its former glory. This takes place during two back-to-back songs. The first of these focuses on the importance of a people's link to their land. The depictions of people leaving their home on foot and in trails of ox carts would have had particular resonance for all those Indians directly and indirectly involved with the Partition exactly ten years before the film's release. This is especially poignant in the second song which celebrates the village's rebirth marked by a successful harvest when a high-angle shot reveals a pre-Partition map

of India created from golden hay. The song also accentuates Radha's role as icon when her appearance seems to impersonate the statuesque quality of communist statues, reflecting Mehboob's own political inclinations. *Mother India* has become an icon of Bollywood. In complete contrast to this image of a strong woman, one of the most enduring of the cinema's male figures has been Devdas, the tragic lead character and namesake of Bengali writer Saratchandra Chattopadhyay's book published in 1917. There are several themes in the story including unrequited love, caste, alcoholism and the difference between life in the rural and urban worlds. The story has been adapted for screen numerous times and the version discussed here is Bimal Roy's reserved and sensitive adaptation from 1955.

Devdas (Dilip Kumar) returns from his studies in the city to his rural home and falls in love with his childhood sweetheart Paro (Suchitra Sen). Paro has always loved Devdas and has held a candle-light vigil since his

A pensive Devdas
played by Dilip Kumar.
© Bimal Roy Foundation

departure. His father refuses his son's wish to marry Paro as she is from a lower caste. Devdas is unable to fight for his love and soon Paru's marriage is arranged to a much older widower. Devdas visits Paro on her wedding night and asks her to marry him but she declines. Devdas returns to the city where he meets the prostitute Chandramukhi (Vyjamanthimala) who falls in love with him. Following his father's death, Devdas inherits money that he drinks away leading to his developing cirrhosis of the liver. Before dying he wishes to see Paro one last time but instead dies outside the threshold of her house.

Devdas is a tragic story, and its central theme is of the father-fearing son who is unable to stand up for himself and his true love. He is emasculated, and spirals towards his own self destruction; there is no hope for him as he is deserted by family, friends and community. Religion is absent and he is unable to find love in the arms of the one person who is able to offer comfort, the prostitute Chandramukhi, due to his ambiguous feeling towards her. *Devdas*'s inherent nihilism reverses popular assumptions about the hero in Bollywood, and in so doing it demonstrates that this cinema is far from simple in its charcterisations.

Villains and Vamps

Villains come in several types depending on the genre or setting of the film. They vary from the urban underworld don involved in black market trade to rich upper-caste landowners who threaten the chastity of village belles. Other villains include politicians and rich Brahmins. These figures use their powerful positions to manipulate the poor, to take advantage of women and emasculate the men around them. They are immediately recognisable by their appearance and clothing – often traditional – which marks their social position or caste. No matter who the villain may be, one of the great unwritten rules of Bollywood is that he should never perform a song and dance number.

Villains often have recognisable physical traits including scruffy beards and slicked-down hair. These attributes construct an appearance which contrasts to those of the clean-cut and clean-shaven hero. He is also recognised by his clothing. For those who inhabit the underworld, this includes long, cloak-like jackets, polished and pointed shoes or boots and gold jewellery displaying a narcissism similar to that of the

Franco-American gangster (see Bruzzi 1997: 67). A staff or cane may also be carried, particularly by older villains. Not only does this suggest a physical disability but it also suggests 'phallic panic'. This suggestion is furthered as so much of the villain's attributes are displayed on the outside, for example fast cars and extravagant homes which are guarded by a team of henchmen. The latter are usually recognised by their dishevelled appearances, which primarily include thick moustaches and stubble and tall and bulky frames crowned with sneering grins and teeth stained by *paan* (a popular and mildly intoxicating palate cleanser containing betel nuts and spices).

The antithesis of the romantic heroine is the vamp and her mark of distinction is an association with unrestrained sexuality. This may be seen in her characterisation: a prostitute, cabaret singer or gangster's moll who lives outside of the confines of familial settings. The vamp has only been played by a few actresses – in particular Nadira and Helen. What is interesting about these actresses is their background. Nadira was the daughter of Jewish Indians and Helen was a Christian born in Burma, whose family fled to India during World War II. The physical difference and exoticness of these stars seems to have typecast them in these roles and possibly made their moral transgressions and sexually-charged behaviour more acceptable for audiences. Helen often made cameos in scenes featuring theatres, nightclubs and cabarets (see Pinto 2006). For these numbers, she would be in non-Indian clothing, always outlandish and often bizarre, including a cockerel feather-inspired outfit donned when dancing on a bar in *Jewel Thief* (Vijay Anand, 1967), and gypsy chic in the song '*Mere Mehbooba o Mehbooba*' in *Sholay*. Her hair and make-up enhanced her vamp appearance: long nails, the application of elongated eyeliner (enhancing and further fetishising her fairness and South-East Asian roots), highly stylised but loose hair and a sultry pout. Her exoticness is highlighted in the lyrics of a song she performs in *Howrah Bridge* (Shakti Samata, 1958) in which she proclaims herself as a Orientalist fantasy, naming herself Chin Chin Chu and claiming that she has had adventures with both Aladdin and Sinbad.

An interesting aspect of Helen is her appeal to female audiences. Women of older generations admit that she was a figure of enjoyment – ever youthful and providing pleasures with her '*jutkas* and *mutkas*' (a common term for provocative dance movements) but never a figure of

evil. This view may partly be due to her often playing the role of a working woman who is forced to become a performer or dwell in dens of iniquity due to financial pressures.

Gay, Lesbian and Transgender characters

Dosti is a term that describes the friendship between two men. It is a recurring theme in the cinema which has spurned some of the greatest successes, including the aforementioned *Sholay*. From the mid-1970s to mid-1980s, *dosti* in films was held to be of greater importance than any other relationship, including familial or romantic. Such relationships are often seen as being more earnest than relationships between brothers. While biological brotherhood is seen as being one of the strongest bonds in the traditional family, it is interesting that films often question the validity of this belief often through the use of a good brother/bad brother set-up. *Dosti* relationships might also be interpreted as homoerotic. In *Sholay* Veeru and Jay toss a coin to see who can have the girl they have both spotted. Instead of landing flat it lands on its side. However, while this may provide opportunity for subversive sexuality, the reason for the throw (heterosexual desire) and an understanding of *dosti* suggests that the positioning of the coin symbolises that no one can break the binds of this particular relationship. Alongside words for friends such as '*dost*', the characters of *dosti* films often use terminology which is used between brothers including the term 'brother' and its Hindi equivalent '*bhai*'. This in itself suggests that there may be no intended homoerotic subtext behind the characters but that the homo-social or homoerotic reading is down to audience interpretation. One also has to take into consideration the historical and social circumstances within which these films were made, primarily the mass migration of men into cities during the 1970s, leading to the splintering of traditional families and the need to form new bonds.

In recent years there has been a string of films in which homosexuality is presented as an accepted part of Western culture. In *Kal Ho Naa Ho*, set amongst the Diaspora community in New York, the maid (played by Kantaben) continually misconstrues the relationship between the two male characters played by heartthrobs Shah Rukh Khan and Saif Ali Khan. Here the mistaken homosexuality is used to create moments of comedy. In *Kabhi Alvida Naa Kehna*, again set in New York, a passing character

Poster for *Dostana* featuring Kunal (John Abraham) in the foreground, separated from Sameer (Abhishek Bachchan) by the love interest Neha (Priyanka Chopra). © Dharma Productions

states he is gay to which Shah Rukh Khan's character smiles and replies: 'Good for you.' It could be argued that these types of scenes are derogatory as they refuse to take homosexuality seriously but at the same time it could be argued that the suggested acceptance of homosexuality offers moments of deviant pleasures. In addition, these scenes become sites of pleasure for gay audiences. *Dostana* (Tarun Mansukhani, 2008) was the first Bollywood film to deal with homosexuality at its core. Although it shies away from displaying a real gay relationship, it provides a middle ground to discuss the insecurities surrounding the issue in Indian culture and makes room for its acceptance by the institution of the family. At the centre is a comic narrative in which two men pretend to be a gay couple to compete for the love of a woman. Homosexuality is not deemed a comic element here although humour is found in the protagonists' attempts at being gay and their moments of discomfort. Although hypothetical, the film's treatment of the acceptance of homosexuality is extremely moving. The mother finally accepts her son's sexuality and explains she cannot

work out why or how it fits into society but for her it is God's decision and she still loves him. She approaches her son's 'boyfriend' to perform the ritual ceremony of accepting a daughter-in-law into the home. Noticing the loving sincerity of the mother's actions, he accepts the ritual and the gold bangle she gives from her own wrist (a traditional gift bequeathed by a mother-in-law to a new bride).

Lesbianism has been more directly addressed by the cinema. Two particularly sexually-charged moments occur in historical films. In *Mughal-E-Azam* a brief kiss occurs between two women, including the chief villain of the film, Bahar, and one of the subordinate ladies of the harem. She looks in Bahar's eyes, takes her cheeks in her hand and plants a kiss on her eyelids. One of the most infamous lesbian scenes was in the historical film *Razia Sultan* (Kamal Amrohi, 1983) where Khakun (Parveen Babi) draws a feather over her face and seems to intimately kiss Razia (Hema Malini). Perhaps the most evident representation of other sexualities is that of India's *hijra* society which includes transgender, transsexual and homsexual individuals. The *hijras* of India are a group that remain outside the heterosexual social structures of Indian society but who have also managed to successfully survive in their own particular social milieu. Their society consists of a central guru who keeps charge of several individuals (*chelas*) whom 'she' guides into full *hijra* status. They worship Bauchar Maa, a four-armed female deity who rides on a cockerel and whose temple is found in Gujarat in northwest India. Some individuals choose to undergo castration to fulfil personal needs, however this is not true of all *hijra*. Neither is it true that all *hijra* are practising homosexuals. They consider themselves a 'third sex'. Due to social ostracism, some *hijra* are forced into prostitution and begging, however many earn their income from a strong performance tradition of singing and dancing at birth, engagement and wedding ceremonies. These performances are often bawdy and humorous and their high entertainment value has not been missed by filmmakers. The *hijras* in *Kunwara Baap* (Mehmood, 1974) capture the spirit of India's potential openness to differing sexualities during the song '*Saj Rahi Gali Teri Maa*' ('Dear Mother, the entire street is adorning their homes') as crowds of people, including children, sing and dance with *hijras*. Similar scenes occur in *Amar Akbar Anthony* and also *Hum Aapke Hain Kaun…!*

Notes

1 My thanks to Rajjat Barjatya for his insights into these issues.

2 A look at several of the most popular films suggests differing roles for the father figure. At times the father appears to be typecast as a domineering figure, upholding tradition and demanding the son or daughter's adherence to duty, particular in the areas of marriage.

3 While social reforms have aimed to change practices and attitudes in regards to daughters, there are times when one comes across grim stories and grim readings. India has one of the highest rates of female infanticide and the abuse of girls in terms of denial of education, forced employment and early marriage are still common.

4 A number of stars have come from South India with some being trained in classical Indian dance, such as Bharat Natyam, and appearing in South Indian movies before their move into Bollywood.

5 Vladimir Propp in *The Morphology of the Folktale* (1928) and Joseph Campbell in *The Hero with a Thousand Faces* (1949) have discussed this scenario in Western cultures as providing an opportunity for the hero to pass from boyhood to manhood within a liminal space where his masculinity is tested and proved.

4 SETTINGS AND STYLE

Cinema maintains audience interest and steers relationships with characters both through the manipulation of framing and the exchange of looks. The issue of the frontal address and *darshan* was briefly discussed earlier in regards to the adoption of popular calendar art into the religious sphere during the late nineteenth and early twentieth centuries. Rajadhyaksha (1987) has demonstrated that this convention was also apparent in the mythological films of Phalke, where the gods appeared centrally framed, bestowing blessings on devotees both within and beyond the frame. These particular studies locate the use of *darshan* in religious or pseudo-religious circumstances, but it has also been argued that it is possible to ascribe this way of seeing beyond the divine image.

Both Ravi Vasudevan (2000) and Madhava Prasad (1998) claim that *darshan* may also refer to political, social and familial relations so that 'social status derives from the degree of access which social groups and individuals have to a central icon of authority, whether of kingship, divine authority, or the extended patriarchal family and its representatives' (Vasudevan 2000: 139). In other words, authoritarian figures control the power of the darshanic gaze. However, the experience of *darshan* in a religious context is interactive, complicating its application to character/audience relations in the cinema. It involves various stages, including bowing before the deity (and perhaps representations of their attendants); performing ceremonies such as the presentation of food and the decoration of the divine image with garlands; the worshipper may even circumnavigate the deity or shrine.

Darshan does not only involve the worshippers viewing of the deity, the 'look-back' from the deity is just as important.[1] Within Hinduism the returning gaze is considered extremely powerful and this is often depicted in films with the image of the deity performing miracles, for example sparkles or beams of light emerging from the eyes. The theory of *darshan* cannot be applied universally and the viewer should always contextualise the gaze within the context of the narrative, characters and cultural settings.

Many of the settings and scenic conventions of Bollywood film have been discussed by Rachel Dwyer and Divya Patel (2002). These include domestic and social locations and transgressive and authoritarian spaces. These are familiar settings for any regular viewer of the cinema, and I elaborate and build upon these below.

Locations

The homes of the wealthy are marked by their immense size and a specifically grandiose style. In *Andaz* the home contains a large swirling staircase and a number of European artefacts, including Romanesque statues, wooden furniture and large family portraits. These types of décor are also apparent in later films and are prerequisites if creating a super-rich ambience. The inside of the homes of the super-rich are often constructed with a specific topography. The living-rooms contain sunken seating areas with the surrounding ground level used for the placing of other furniture which may include pianos, ornate lamps and potted palms. Most importantly they play host to huge staircases, which have become the most obvious signifier of a character or family's super-rich status (see Dwyer & Patel 2002: 71–3). Not only does the staircase separate the public family space from the private family space, it also symbolises ascension to wealth. The staircase emphasises bourgeois values and it also gives a sense of grandeur and of the epic, turning family stories into dynastic sagas. The staircase may be straight and centralised as in *Bobby* or swirling and positioned in the corner of the room as in *Andaz*. Double staircases joined together by a balcony are another reoccurring feature, used for welcoming ceremonies during weddings as in *Hum Aapke Hain Kaun...!* as well as frequently being the place where romantic couples first see each other.

Bourgeois homes have become increasingly ostentatious. In *Hum Aapke Hain Kaun...!* the home has a modern exterior and is surrounded by

large lawns that are used for recreation including family games of cricket. This recent emphasis on using spectacular domestic settings is most evident when comparing the adaptations of *Devdas*. In Bimal Roy's version discussed earlier, the zamindar's house is a large but realistic building built on four sides overlooking a central courtyard. In Sanjay Leela Bhansali's most recent version (2002) the home is a vulgar mansion built of an unrealistic mixture of multi-coloured glass and marbled floors, clearly influenced by modern ideals rather than demonstrating historical accuracy.

There are two types of home which show the lives of the poor: the farmer's home and the house in the urban slum. The farmer's home is often shown as barren, or it is slowly stripped of fineries and then necessities as occurs in *Mother India* where the idyllic family home, covered in folk art, wall hangings and auspicious door decorations (*torrans*), becomes darker and emptier as the plot progresses, until its final destruction by floods. The homes of the urban poor are the antithesis of those of the super-rich, usually confined to a single room and comprising of only one storey. There are no gardens or courtyards with the street outside offering a mixture of community and chaos. Dividing the inside and the outside are the windows that are usually very small and a sense of claustrophobia is caused by the placing of vertical iron bars across them. While these suggest security they by no means promise privacy, as those on the outside have constant access to peek in or speak to those on the inside. However, films often romanticise the slum. The physical proximity of people and their dwellings is the perfect setting for the forming of alternative extended families. There is also a sense of 'having made it' in the city as the one-room shack in the slum is a safe haven compared to exposure on the footpath, which is the place where those new to the city spend their first night. The physical randomness of the slum contrasts to the clean lines of government institutions.

Dwyer and Patel (2002: 76) note that the courtroom is the longest-standing building in Film City, one of the key locations for shooting Bollywood films. A colonial legacy, the modern court is more or less the same as any in the West with members of the judiciary often using English language. There is a certain level of homogenisation seen in the pictures of Gandhi and the Prime Minister of the day. The Indian legal system, including the police, is often represented as corrupt and unable to deliver justice. The courtroom features heavily in *Insaf Ka Tarazu* (B. R. Chopra, 1980) when Bharti Saxena (Zeenat Aman) seeks justice after becoming

the victim of rape. Here the court is seen as a cruel and unsympathetic place which calls a minor (Bharti's sister Neeta, who witnessed the rape) to the stand. The court case releases the rapist without charge and he later goes on to rape the younger sister. B. R. Chopra presents this scene in a moment which echoes Soviet montage. The rape of the girl is compared to the loss of faith: as the rapist approaches Neeta, Chopra inserts a shot of a temple being smashed to pieces as it is struck by lightning. The rape is aligned to the breakdown of morality, faith and humanity (represented by the temple), thus heightening the corruption of the courtroom and its failure to protect the innocent.

The hospital is featured regularly in films and it is often the site of revelations, particularly due to the prominence of major events such as births and deaths. The rich have the privilege of receiving medical care at home; this usually involves visitations by a family doctor but also the presence of a female nurse to administer personalised care. Hospital stays are undertaken by the middle classes with the poor often relying on family members to care for each other whilst struggling to obtain medicines. The Indian hospital is seen as a pinnacle of the successful modern state where the marvels of modern medicine are demonstrated (Dwyer and Patel 2002: 76–7). In *Amar Akbar Anthony* the three sons provide blood for a transfusion which, unknown to them, is used to save their mother; in *Coolie* (Desai, 1983) the father donates a kidney for his son. Both of these films include operation scenes that are often filmed using a tidy shot/reverse-shot pattern including the patient's view paralleled by the staff's view. But there is also an ambiguity associated with modern medicine as in both of these films some form of miracle occurs.

In *Coolie*, prayer complements medicine during an emergency operation that follows a shooting. As each bullet is removed from Iqbal (Amitabh Bachchan) the camera cuts away to shots of his Muslim family and then his Christian and Hindu friends at prayer, their parallel efforts ensuring that the operation is a success. Both of these films also include scenes of medical conditions being instantly cured by divine intervention. In *Amar Akbar Anthony*, the mother's blindness is cured by two droplets of light emerging from the eyes of a statue of the saint Sai Baba of Shirdi. These travel across the screen and land on her eyes. In *Coolie* the mother suffers from a form of amnesia which is maintained by the villain through the regular administration of electric shocks given by medical staff under his

private employment. Her condition is cured when a religious article with words from the Koran lands on her head and restores her memory.

The inclusion of some form of staged variety show is used in many films and this is particularly important if we think of Bollywood as a cinema of attractions. Producers also have their own vested interest in celebrating the skills of the performers it has employed who are given ample opportunity to demonstrate their artistic attributes, in particular dancing.[2] The presence of a theatre show allows the pleasures of song, music and dance (often combined) to be set in a realistic context. This is evidenced by the use of shots taken from the view of the diegetic audience, either from a protagonist's view or a centralised view, which includes the proscenium arch or footlights. The use of the theatre show as part of a cinema of attractions is seen in *Diamond Queen* (Wadia, 1940) where the protagonists attend a variety show, which includes singing, dancing and magic acts. However, it must be added that these scenes often contain swift changes of sets and clothes which displaces them out of the real world into fantasy.

In Dev Anand's 1965 film *Guide* (based on the novel by R. K. Narayan) Rosie (Waheeda Rehman) fulfils her life-long dream of becoming a renowned dancer. The song '*Piya Tose Naina Laage Re*' ('When I first caught sight of you my love') provides a context to show Rosie's change from a novice dancer to celebrated performer. She performs dances in numerous styles and performs these on varying stages ranging from a humble floor and marquee at a local dance competition to elaborate sets complete with backing dancers.

Another context for using the stage is the awards ceremony, where individuals are honoured by local establishments such as schools or colleges and authorities such as the police and government. Here, the community, state and law are often seen to be honouring hard work and commitment to duty, therefore providing insights into political, social and cultural ideals. Quite often the two contexts overlap, for example in theatrical competitions where an individual receives awards. The public space can also act as a place for the veiled exposure of private desire as in *Mere Mehboob* (Harnam Singh Rawail, 1963) where Rajendra Kumar sings the song '*Mere Mehboob Tujhe Mere*' ('You, my love'), which describes his experience of falling in love with a woman in a *niqab*, just by seeing her eyes.

Classed as a 'transgressive space' (Dwyer & Patel 2002: 68), the cabaret was a favourite location during the 1960s and 1970s. It offered a number

of pleasures – sexual, visual and musical. It was the location for fantastic dance numbers performed by girls wearing skimpy and outrageous outfits and outlandishly-styled backing dancers. These cabaret spaces normally included a dining area and bar with some form of stage often with a dancing area in front. The lead characters could appear on stage as performers, be seated spectators or, use the extravaganza or stage as a backdrop for subterfuge.

The sets of cabarets were often fantastical in appearance as in *Aasha* (M. V. Raman, 1957). During the famous song 'Eena Meena Dica', set in a ladies-only cabaret, Vyjayanthimala frequently changes costumes and at one point the backing dancers appear by magic holding onto large candles. In *Teesri Manzil* (Vijay Anand, 1966), which has one of the most famous cabaret scenes, Helen dances in a flamenco dress and a long shot reveals her to be the swirling iris in a giant eye. In *Namak Halaal* (Prakash Mehra, 1982) the setting for the cabaret is an island surrounded by a small moat. The band appears to be Afro-Caribbean but full of tribal caricatures, a motif also used in *Mr India* when Sri Devi performs the song 'Hawa-Hawaii'.[3]

In recent years, the spectacle of the cabaret scene has been sidelined by the nightclub which often appears in films dealing with the Diaspora. The mobility of stars in these locations is very different to those in the cabaret. Here, the key protagonists are often the revellers, leading other attendees to follow in their footsteps. The surrounding crowds are often suggestive of a new global culture that is heavily multicultural with Indians fully integrated in the fun. They are often full of sexy blonde girls, trendy young men and usually Afro-Caribbean dancers who often deliver a rap in the bridge of the song. One development has been to present heroes and heroines drinking alcohol, something that has traditionally been seen as taboo. These scenes highlight important social and moral issues in Indian society and they can be seen as sites of negotiation for the upwardly-mobile classes who are exposed to new urban sites of pleasure both within and outside of India.

Away from the city, non-agricultural land, including woodlands, hills and parks, are associated with erotic love and are a favourite location for dream sequences. They provide plenty of opportunity for embracing couples to move out of view behind foliage, suggesting some form of sexual activity. Flora, fauna and the seasons have particular symbolic relevance. Flowers suggest fertility as well as the abundance of water and a cooler

climate. Specific flowers are favoured, in particular members of the dahlia and monocot families; dahlias often appear in woodland dream sequences while parks contain tulips, most famously in *Silsila*; tulips are often a term of reference in Urdu love poetry so their appearance in these situations suits the language of love. Agricultural land has its own particular symbolism: in *Dilwale Dulhaniya Le Jayenge* and *Pardes*, the opening shots of Punjab show fields of yellow mustard flowers. While successful harvests have much of the connotations suggested above they also present India as a land of fulfilment and plenty: a promised land of self-sufficiency. In *Dilwale Dulhaniya Le Jayenge*, the cultivation of the land represents established social and familial order which the father hopes to find in the land of his birth. The ideal of a controlled agriculture is also apparent in the opening and closing scenes of *Mother India*, which shows mechanised and irrigated farmlands symbolising both literally and metaphorically, the control of the wild.

Animals have featured in film narratives including elephants, monkeys and snakes. Hinduism has a number of hybrid gods and most popular are the elephant-headed Ganesh and monkey-headed Hanuman. An elephant is a central character in *Haathi Meri Saathi* (M. A. Thirimugham, 1971). While elephants are not seen as personifications of Ganesh, languor monkeys are seen as personifications of Hanuman; however, it is macaque monkeys which have been used in films for comic effects, which include pranks such as stealing clothes and even driving cars. Cobras are probably the most frequently occurring animals in movies. This is partly due to their appearance in Snake Films (see above) but they also appear in other narratives as in *Amar Akbar Anthony* when the blind mother of the hero runs away from bandits and heads towards a temple and moves through the entrance, a cobra descends from the doorway frightening off her pursuers. Despite being set in an exclusively Muslim world *Pakeezah* has a cobra which protects Sahib Jaan by guarding her room and killing a potential rapist. A cobra is used to divide the differing values of the East and West in *Pardes* when one appears in a bedroom, the Indian girl bows before it but her American born suitor panics in fear.

Pet animals are kept by the upper and upper-middle classes but it is usually working animals that are kept in the home. The association between birds and freedom is seen in *Maine Pyar Kiya* when the heroine saves a pigeon from being shot and sets it free. The most famous bird to feature in a film is the hawk Allah Rakha in *Coolie*. Allah Rakha looks

after the hero and his colleagues, transporting messages and attacking villains in scenes which are reminiscent of the heroic vulture Jatayu in the *Ramayana*. Dogs are not a common pet in India but they have been used in movies as a symbol of affluence, as in *Hum Aapke Hain Kaun..!* where the family's pet dog Tuffy is used by the gods to change the fates of the film's heroes and create a 'happy ever after' ending.

Shelter from the wild is found in the log cabin, however it is also recognised as a space for sexual transgression (see Dwyer & Patel 2002: 70–1). Such cabins feature in the great romance films *Bobby* and *Junglee* (Subodh Mukherjee, 1961). In both of these films the cabin is situated in Kashmir, a location that is associated with romance and paradise in the popular imagination. Young lovers are forced into a situation where they cannot leave the house: locked-in in *Bobby* and snowed-in in *Junglee*.

The general consensus of avoiding the depiction of kissing, let alone sex, has caused the cinema to create particular ways of representing the erotic and a favourite setting is the monsoon. The monsoon's arrival is associated with fertility and therefore has erotic and romantic connotations. It features frequently in movies marking the moment when couples fall in love but also share their first sexual moment, sometimes resulting in wet sari scenes (see Dwyer 2000b: 143–59). One of the most famous of these occurs in *Mohra* (Rajiv Rai, 1994) during a particularly explicit song between Amar Saxena (Akshay Kumar) and Roma (Raveena Tandon) called '*Tip Tip Barse Parni*' ('The rain is tipping down'). When Amar first spots Roma she looks like a ghostly apparition dancing in front of a swirling spiral of light. The combination of rain and wind adds to her alluring mystery as it contorts her sari in different directions. These images are inter-cut with various fetishistic shots of her body, in particular the waist and breasts that thrust and throb to the music. During this early part of the song, Amar objectifies Roma who dances for his pleasure and excitement, emphasised in the shots when she rubs herself against his body. While these moments accentuate the image of woman as a site of desire this is somewhat devalued by the integration of Amar as a participant in the spectacle. Ripping his jacket off, Amar participates in equal amounts of thrusting with his see-through unbuttoned shirt revealing his soaking chest hair.

Festivals also act as locations for sexual transgression. A favourite festival of filmmakers is the Hindu spring festival Holi that also has associations with fertility. The festival is a re-enactment of the teenage Krishna's

playfulness with the village cowherd girls (*gopis*) and the most visual ritual of the festival is the throwing of multicoloured powder paints and liquid dyes. This sexual scope of the festival is played upon in the cinema in two of the biggest films *Mother India* and *Sholay*. In *Mother India*, the festival acts as an opportunity for physical interaction between men and women. Birju (Sunil Dutt) uses this as an opportunity to grasp the wrists of the moneylender's daughter who has wound him up by wearing his mother's bangles. In *Sholay* the festival acts as an opportunity for Veeru and Basanti (Hema Malini) to express their fondness for each other. What is noticeable about both of the song sequences is the positioning of the widow, who remains outside of the celebratory space. In *Mother India*, Radha reminisces on her previous experience of the festival when her husband was still alive, allowing her to partake in the festivities. In *Sholay*, the widow remains at a further distance and within a temple on a nearby mountain. Her isolation from the festival is enhanced by her plain white sari, contrasting against the black and barren rocks which frame her.

CASE STUDY: Junglee (Subodh Mukherjee, 1961) / *Kabhi Khushi Kabhie Gham...* (Karan Johar, 2001)

Junglee is a romantic comedy that tells the story of Shekhar (Shammi Kapoor), a rich and stuffy young man who, alongside his sister Mala (Shashikala), lives under the thumb of a hysterically powerful matriarch (played by Lalita Pawar). When Mala declares she is in love, her mother commands Shekhar to take his sister to Kashmir for some respite. Rather than being a place to bring one to their senses, Kashmir is a transgressive space which qualifies Mala's relationship and puts Shekhar in touch with his own emotions when he meets and falls in love with Raaj Kumari (Saira Banu). The film is important as it embraces romance and proves love to be an essential human and life-changing emotion when it changes Shekhar from a repressed individual into a wild spirit ('*junglee*').

The turning point in their relationship occurs after the two are caught in a snowstorm and seek refuge in a log cabin. What exactly happens here is quite ambiguous. Raaj Kumari collapses before entering the cabin and Shekhar has to carry her in. The next shot is of a roaring fire and the camera pans left to show Raaj Kumari waking from sleep but noticeably her shoulder and upper arms are bare and she is wrapped in a blanket. While the

sex act is only suggested, much effort is made to ensure the log cabin is the locus for the blossoming romance, not sexual relations. The two sneak peeks at each other from under their blankets whilst eating and sleeping. Whilst Raaj Kumari is sleeping, Shekhar stares at her and realises he is in love. He has to literally cool himself down and steps out into the storm and distracts himself by chopping wood.

It is only after this moment that Shekhar begins to peel away his stifled exterior, sitting next to the fire and reciting poetry through which he declares his love. The camera lingers on the faces of Shekhar and Raaj Kumari, beautifully lit in the firelight as voiceovers declare their feelings for one another. The ambience is later shattered when the storm outside smashes a window and blows their remaining food onto the floor, a metaphor for the external storm which will ensue once their families are made aware of their relationship. Shekhar prays to God to halt the storm and his prayers are answered. He emerges from the cabin and in the film's most memorable scene he repeatedly shouting 'Yahoo!' before the two roll and dance around in the snow amongst wide vistas. The free setting of the sunny and snow-covered wilderness is the antithesis of the entrapment of Shekhar's home and the ever-watchful eyes of his mother, who lords over her domestic castle via her headquarters in a secret underground bunker. As has already been suggested, the grand home is often seen as a place of coldness and this comes across in the ostentatious settings of *Kabhi Khushi Kabhie Gham...*

The Raichands are a successful Indian family headed by the patriarchal Yash (Amitabh Bachchan) and his submissive wife Nandini (Jaya Bachchan). They have two children. The eldest, Rahul (Shah Rukh Khan), was adopted at birth. When the younger brother Rohan, (Hrithik Roshan), is away at boarding school, Rahul has a love marriage with Anjali (Kajol) and is subsequently ostracised by his father. On finding out the news, Rohan vows to bring the family back together. The story has clear influence from the *Ramayana* with Rohan showing the brotherly devotion of Bharat and Lakshman when their brother Rama is banished from his home. This is suggested in the shot that precedes the interval where Rohan states his vow and is framed next to statues of Rama and Sita, occupying a position usually held by Laxshman in popular religious images.

The Raichand's family home has features that are symptomatic of the urban super-rich household. The heart of the home is the family temple

A delightful dénouement. Yash (Amitabh Bachchan) is surrounded by his reunited family. Still from *Kabhi Khushi Kabhie Gham...* © Dharma Productions

with a shrine framed by a double staircase with carved wooden pillars and a marble floor. However, despite the abundance of material wealth this is a largely cold and unemotional space devoid of human warmth. This is symbolised by the fire in the living room which fails to illuminate the surroundings and instead appears to be stifled in the shadows and darkness which permeate the house. The house is surrounded by parkland and is totally isolated (departures and arrivals need to be undertaken by helicopter).

The extravagance of the home contrasts to the middle-class homes of others in the narrative, noticeably the home of Anjali and her friends, who live in the bustling Chandni Chowk district of north Delhi, running hither and thither between each other's homes and talking to each other from their balconies. The homes also relate to the behaviour of their residents. In the song '*Say Shava Shava*' (translated as 'Say yeah yeah!'), performed at a birthday party in the Raichand household, Western-style dance is performed complete with skimpily-clad girls. This is inter-cut with traditional and family-orientated celebrations in Chandni Chowk where all the community take part in celebrations that weave through the apartments and streets.

Style

As evidenced in the discussion of dream sequences, Bollywood has a rich visual palette conveying meanings and messages which direct and titillate the audience. This includes the way in which the sex act is negated but is also seen in the other visual delights of dancing, fight-scenes and costume.

Bollywood's use of dance is one of its most exciting and enticing pleasures.[4] Dancing ability is a prerequisite for actors and actresses who wish to play leading romantic roles. Many leading ladies have had training in classical Indian dance, in particular those from South India, such as Vyjayanthimala, Hema Malini and Sri Devi.[5] Choreographers have often been women and one of the most notable names in Bollywood today is Farah Khan, who is a regular choreographer for blockbuster hits and has worked in Hollywood. She became a hugely successful director with her second film (*Om Shanti Om*, 2007) set in 1970s Bollywood and featuring dozens of cameos by Bollywood's elite. Saroj Khan is another key choreographer in Bollywood.

Dance scenes are often used for the inclusion of spectacle. They normally involve masses of troupes performing movements and wearing costumes co-ordinating with the protagonists, so the backing dancers also become an essential part of the *mise-en-scène*. The types of dance used in films vary greatly drawing on classical and folk, traditional and regional and hybrid fusions as well as foreign and modern dances. Traditional dances are presented in an updated fashion even when danced as part of a staged performance, due to the need to create spectacle and offer visual pleasures. However, these are still seen as belonging to an Indian tradition, especially when compared to the dances inspired by Western influences. Whole films have been based around the spectacle of dance. These largely incorporate dance as part of the character's working life, allowing dance sequences to be placed within a realistic timeframe and geographical space. These include R. V. Shantaram's spectacular *Jhanak Jhanak Payal Baaje* (1955) followed by *Navrang* (1959), which included dances (one brilliantly performed by a handsome elephant) heavily inspired by India's various classical and folk traditions. The modern and urban world of music, rock concerts and stage shows has been celebrated in *Dil To Pagal Hai* (Yash Chopra, 1997) and *Taal* (Subhash Ghai, 1999).

In Hollywood the dancing male body has often been seen as femi-
nised, not only because it is indulging in what might be considered to be
a less than masculine pursuit, but also because of its situation within the
musical, a genre that is most often associated with women and gay men.
In terms of Hollywood, it has been argued that the potential for the male
dancer to be an object of the erotic gaze in these roles is denied because
male dancing stars often partake in highly athletic or acrobatic acts making
their appearance more an act of sportsmanship (see Cohan 1993). This is
a difficult position to maintain when looking at Bollywood films because
male characters do not always lead and often dance in unison with females
by undertaking the same movements. Fan discussions often mention the
physical agility of the star's body and its appropriateness to dancing, with
many stars being considered overweight or too old to dance. These are
erotic judgements, suggesting that dancing ability has particular connota-
tions, of healthiness and stamina. But these are also social and cultural
judgements with the star being seen as cutting-edge and 'cool'.

Perhaps providing an opportunity for the realignment of gender bound-
aries are the equally choreographed fight scenes – also known as 'thrills'.
These are quite fantastic, with the hero often taking on whole battalions of
baddies and coming through only partly scathed. Various camera tricks are
used to create fantastical stunts and this is particularly evident in the films
of the 1970s. Film may be played backwards so that the fighter seamlessly
jumps back and up onto buildings and walls, or it may be sped up thus
enhancing the frantic tone of the action. These conventions also heighten
the presence of the star body as a supernatural entity and this is particularly
poignant as similar conventions are often employed in the Mythological
film, particularly those involving the monkey-god Hanuman as he fights
demon warriors.[6] In addition, the use of loud sound effects used during
kicks and punches enhances the attribute of the star's strength. However,
by making the violence stupendous the films simultaneously make these
scenes less sadistic and therefore more digestible for audiences, resulting
in a cinema of spectacular entertainment rather than a cinema of violence
and sadistic horrors.

Yvonne Tasker has argued that in Hollywood films the action hero may
either represent a celebration of 'traditional masculinity' or a masculin-
ity that is 'in crisis' (1995: 109). Tasker's first category can apply to the
'angry young man' characters of the 1970s who often took part in urban

brawls, just in order to survive. The idea of a fighting man as a celebration of traditional masculinity is particularly interesting if we consider the 'angry young man' to be a rebellion against previous romantic hero figures of the cinema. It also works on a more political level, as he could be seen as symbolic rejection of the ideal of the peaceful and non-violent man, personified in Gandhi and evoked through the sad romantic hero of the cinema during the 1950s.

The celebration of a traditional masculinity has particular resonance for Amitabh Bachchan who often performed his own stunts. During the filming of a fight scene in *Coolie* he was seriously injured and rushed to hospital. The celebration of Bachchan's strength in both doing his own stunts and surviving the accident is celebrated in the movie when it suddenly freezes and text appears on the screen marking the moment that he received his injuries. Although on one hand this in-situ moment dissects the spectacle of cinema and exposes its apparatus and the vulnerability of the star, the very risk of breaking the verisimilitude highlights the huge importance and popularity of Bachchan as a star.

Clothing and Identity

Clothing plays an crucially important role in *mise-en-scène* and also provides pleasures for the audience (see, for example, Dwyer & Patel 2002). In *Pukar* (Sohrab Modi, 1939) a human chess game takes place in the court of Jehangir. The camera tracks right past a line-up of the players and their headdresses are most exciting. They are each based on animals traditionally used in the royal cavalry: camels, horses and elephants. This scene is not necessary to drive the plot, but it provides us with an example of the further use of costume to create a sense of nostalgic pleasure in the glory of a pre-colonial past. Clothing may be used to symbolise the religion, social caste and regional background of characters. This type of sociopolitical use of clothing was prolific in the pre-independence era. While censors prevented the discussion of anti-colonial sentiment within films, filmmakers used clothes as visual signifiers to direct audiences towards their own political affiliations. For example in *Kismet,* the hero's position as an embodiment of Indian values is marked by his wearing of a turban. This contrasts with the villains and buffoons, who wear classically British clothing, including accessories such as bowler hats and pocket-watches.

In several post-Independence films, teenage women of the upper classes are often seen wearing Western clothes and this seems to signify immaturity as well as the rejection of Indian values. Following the death of her father in *Andaz*, Neena stops wearing her Western clothes and wears a sari, marking both her entry into adulthood and her embracing of Indian values. To some extent, this socio-political use of clothing can still be seen, albeit diluted through the general adoption of Western clothing by men, but present within the more variable dress worn by women, who are seen as symbols and holders of tradition.

The exposure of the female body is still taboo, particularly of women who are at marriageable age and who are indeed married. A simple observation on women's clothing in the cinema would be to suggest that the way a female character is dressed symbolises her social and moral character with the archetype of the good Indian woman wearing Indian dress such as a sari, Punjabi suit or *salwar kameez* and the villainess or vamp donning Western clothing. However, both the relationship between female characters and their clothing and the audience's subsequent interpretation is much more complicated. Since the 1970s, heroines have often worn Western clothing such as jeans and blouses and more recently vest-tops and mini-skirts have become common amongst hip and trendy urbanites. Often the heroine's look is transformed after marriage is proposed and she appears more traditional in appearance. These complications regarding costume are most evident in the quintessential Indian dress the sari, which carries deeply rooted religious, social and – particularly in the cinema – erotic meaning.[7]

Since the late 1990s – and in particular with the films *Dil to Pagal Hai* and *Kuch Kuch Hota Hai* – Western designer clothes have become hugely important signifiers of the successful, internationally-based Indian. The choice of clothes often includes heavily branded goods with labels commonly on display. In recent years India's leading designer Manish Malhotra has regularly designed costumes for leading romantic heroines. His Indian-influenced designs play on traditional Indian garments including the sari, with the addition of highly glamorous twists with heavily embroidered silks and chiffons alongside jewel-encrusted bodices.

There are many examples of cross-dressing to be found in Bollywood.[8] In *Vested Interests*, Marjorie Garber (1991) argues that cross-dressing narratives often work to further the cause of the heterosexual characters through what she calls 'progress narratives'. These narratives involve the

subversion of sexual identity for the heterosexual hero/heroine to further or reinstate his/her position. Moments of 'progressive' cross-dressing are common in Bollywood; instances of women dressing as men occur frequently, particularly within the comedy genre – such as the aforementioned Sri Devi's Charlie Chaplin impersonation in *Mr India* or Saira Banu dressing as a bearded guru in *Junglee*.

Cases of male-to-female cross-dressing have also provided great comedic moments. In *Kashmir ki Kali*, Shammi Kapoor wears a *niqab* to disguise himself as an Afghan woman to meet his romantic interest. *Lawaaris* (Prakash Mehra, 1981) contains one of Amitabh Bachchan's best performances when he dresses as a woman and sings a song about the different physical traits of women and the practical uses that can be made of each (for example a tall woman could be used as a lamp or a large woman could be used as bed). The apparent misogyny in this song could be read in two ways. Firstly that the lyrics reflect a popular commodification of women's bodies but secondly, that the lyrics are making a fool of the men in the audience who admire women for their bodies and nothing else, something which the drag act can highlight and make a mockery of.

Despite variations in style and length, the most celebrated hairstyle in Bollywood is undoubtedly that which is associated with the young bride. Even if a heroine sports a hairstyle that is seen as fashionable for the time, it is always tamed and cultured for the wedding scene whether she is the bride, or partaking in ceremonies as a friend, family member or guest. In the religiously sacred and culturally specific space of the wedding the female star is often the focus of the audience's desires. She becomes a signifier of romantic desires (the young girl wishing to be the bride or the bachelor desiring such a bride); wider familial desires (of their daughter becoming the bride or the bride they wish to bring into the family) and also shared social, cultural and religious desires for marriage: respect for tradition and the potential success of a neo-traditionalism including adherence to religious practices and the promise of the continuation of the family. Hair is important here as its culturing represents the containment of the character and the culling of transgression.

While women's hair has religious links and therefore specific cultural resonance, men's hair is much more ambiguous and is rarely discussed. One of the most interesting aspects of male stars' appearance is their hairstyle and this is particularly true of the heroes of the films of the

1970s onwards. Before this period, hairstyles were generally conservative: full-headed hair but cut straight at the back, possibly as part of a short back and sides and some form of parting with a wave above the forehead. This type of haircut could be seen on many of the stars of the immediate post-colonial period including Guru Dutt, Rajendra Kumar and Dev Anand. Indeed the latter's ability to maintain this look was part of the reason that Dev Anand was known as the 'Evergreen Star'.

Facial hair has an ambiguous place in the portrayal of heroes which goes against public perceptions. Heroes, except for the director stars of the 1950s (such as Raj Kapoor and Guru Dutt), have shied away from keeping a moustache, which is surprising as sporting a moustache is culturally considered to be a sign of biological and social manliness. Male stars reject this norm and their appearance is more like those of gods found in calendar art. For example, images of Krishna as the romantic youth follow particular standards including a clean-shaven face and wavy, shoulder-length hair.

As Dwyer (2002 and 2006a) has also noted, beards have specific symbolism often used in the representation of specific religious groups but also villains. The style of facial hair may also vary with boorish stubble being a significant sign of the outlaw and a well-kept beard often seen on the urban villain (perhaps a sign of narcissistic sophistication). Intellectuals often have white beards, linking them to Tagore and perhaps typical ideas surrounding the look of Hindu sages such as Valmiki (the scribe of the *Ramayana*) seen in popular calendar images. Recently a number of stars began sporting facial hair. Bachchan regularly wears a box beard while his son Abhishek wears designer stubble. John Abraham's trademark facial hair is framed by a straight shoulder-length hairstyle suggesting a specific ideal of urban-cool with many young urbanites copying his style.

The emergence of the 'metrosexual' star has been heavily influenced by the movement of models such as John Abraham into the industry, as well as the emergence and huge popularity of stars such as Hrithik Roshan. Roshan differed from most of the leading heroes before him due to his highly defined muscularity, his wearing of revealing clothing and high standards of personal grooming. Before him there was tendency for the young male hero to have a lean and slim body frame. Older heroes had a somewhat large body frame, which we might term 'chubby' but would popularly be referred to as a 'hero body'. In the past, the display of body hair was common, possibly as a sign to suggest virility. This convention

has become more ambiguous with the rise of stars such as Shah Rukh Khan and Saif Ali Khan, who lack facial and chest hair, while other stars appear with chests covered in body hair in some films but waxed and polished chests in others.

CASE STUDY: *Shree 420* (Raj Kapoor, 1955) / *Khal Nayak* (Subhash Ghai, 1993)

Shree 420 stars the director Raj Kapoor as the lovable vagabond Raju who moves to Bombay where he is befriended by Ganga Ma (Lalita Pawar), the mother figure of the slum area that he moves into. He falls in love with the honest schoolteacher Vidya (Nargis) but is seduced and lured into gambling and vice by the temptress Maya (Nadira). Eventually he discovers the meaning of true love. The title of the film refers to Section 420 of the Indian penal code which deals with fraudulent activity. The names of the charac-

ters have resonance: Raj means Prince, Ganga Ma means mother Ganges, Vidya means knowledge and Maya means illusion.

From the beginning of the film clothes define the characters. The film opens with Raj singing the song 'Mera Jhoota Hai Japani' which has become a populist anthem across India: 'My shoes are Japanese, my trousers are English, my hat is Russian but my heart is Indian.' Raj's appearance is similar to that of Chaplin, including an oversized jacket and tight pinstripe trousers accessorised with a scruffy hat and a bundle on the end of a stick. In one way or another, Raj is never comfortable in his clothing. This is substantiated later when Raj borrows a suit from the laundry

Nargis as Vidya – the embodiment of Indian womanhood towers above Raj (Raj Kapoor) and crushes Maya (Nadira) who represents moral corruption in this poster for *Shree 420*.
© R. K. Films Ltd

he works at to impress Vidya. It is far too loose and his own broken shoes highlight the real person hidden within. Later when Raj acquires wealth his suit fits, but it also represents his entrapment by the seductress Maya and signifies a change in his soul and personal conviction.

The clothes of the female characters become signifiers of their morality. Vidya wears traditional cotton saris and blouses with her long hair kept in a simple and traditional plait. Her contrast to Maya is highlighted after Raj's first encounter with the temptress. A medium-shot of a waiting and natural looking Vidya cuts to a shot of a glamorous Maya wearing a Western dress and sparkling jewellery whilst applying make-up in front of a mirror, representing vanity. Later Raj uses his newly found wealth to buy Vidya a glamorous sari for Diwali. She wears it to please Raj but her obvious discomfort is qualified when she is humiliated by Maya's friends.

The clothes also bring their own pleasures and the film is particularly remembered for Maya's shimmering fish dress that she dons while dancing on a hypnotically spinning table at a party. Its colour, size and exaggerated appearance exemplify the dizzying decadence of a world in which she is mistress.

Khal Nayak, in essence a gangster film, caused a complete scandal when it was released, not because of its subject matter but because of one notorious song, *'Choli Ki Peeche Kya Hai?'*, literally translated as 'What is underneath your blouse?' The song is primarily sung by Maduhri Dixit's character Ganga and is performed in a club. Whilst the music, lyrics and singing style create titillation, it is the dancing body and its presentation that deserve special attention.

Dixit's body was famous for its buxomness, suiting traditional Hindu ideals of the fertile female body that celebrate the breasts, slim waist and wide hips. Ganga wears a take on traditional Rajasthani tribal dress with a skirt, veil and blouse that is heavily embroidered on the breast area and is cut short to reveal the navel. The veil has specific connotations of concealing and revealing, and is used as a significant prop in the dance, its position exchanged from one traditionally associated with women's suppression to an association with active sexuality. The hips are also on display, swinging to the music as the dance begins.

The dance centres around the protagonist by placing her amongst a group of backing dancers who encircle her at several points and at one point bend behind each other to smack each other's behinds. Hip-

Ganga (Madhuri Dixit) struts her stuff whilst indulging in subterfuge with Ballu (Sanjay Dutt). Still from *Khal Nayak*. © Mukta Arts Ltd

thrusting, bosom-heaving and bottom-shaking play a prominent part of what is considered to be sexy dancing in modern Bollywood. To some extent these allow for erotic pleasures but there is also something comic and camp about the movements, ensuring entertainment value for the wider family audience.

Another distraction from the 'sexy' movements is that the dance is infused with elements of the wider narrative by acting as a location for character development and subterfuge. Therefore, the eroticism is further diluted as it is quite clear this is a parading woman with a plan, which involves her using her feminine charms to distract the men she is wishing to outsmart. The potential ridiculousness of these movements is evident elsewhere in the film where Ballu (Sanjay Dutt) and his acquaintances spoof the dance.

Notes

1 My thanks to Gayatri Chatterjee for discussing these issues with me.

2 Primarily I am referring to the female dancing star Helen but also to other stars with backgrounds in dance such as Vyjayanthimala.

3 The use of blackface and unashamed stereotypes in these scenes is

difficult to swallow. As India does not have a black population except for a small group in Western Gujarat and Mumbai, descendents of a former slave trade, it is equally difficult to prove that there are racist elements at work here. It is more likely that the use of such motifs is an example of the cabaret scene's indulgence in the exotic.

4 This has also been one of the main reasons for the cinema capturing the imagination of the West. This is seen through the emergence of Bollywood dance classes, Bollywood work-out DVDs, London's West End show *Bollywood Dreams* and its influence in pop videos.

5 One major male dancer who appeared in many films but is rarely mentioned was Gopi Kishen. A trained classical dancer he first starred in *Jhanak Jhanak Payal Baaje* (R. V. Shantaram, 1955) and later as a dancer in the magnificent *Mughal-E-Azam* (K. Asif, 1961). He continued to be both a choreographer for films including *Umrao Jaan*, as well as starring in classical dance numbers from the 1960s through to the 1980s.

6 For discussions of the use of stunts in Mythologicals, see 'Mythologicals as Stunt Films' (Dwyer 2006a: 42–5).

7 One of the most dramatic scenes in the *Mahabharata* and which leads to the great war in the epic, is the disrobing of Draupadi after she is lost in a wager by one of her five husbands during a game of dice. A Kauruva drags a menstruating Draupadi from her chamber into the playing room, grabs her sari and begins to disrobe her whilst a room full of her husbands, elders and statesmen fail to come to her aid. In desperation she prays to Krishna who magically makes the sari into a never-ending roll of material.

8 Performance traditions involving cross-dressing can be found across India, including the *raas lilas* of Gujarat.

5 STARS AND AUDIENCES

In his essay 'Indian Popular Cinema as a Slum Eye's View of Politics', Ashis Nandy draws a parallel between the popular cinema and the slum which he sees as sharing 'lower-middle-class sensibilities' (1998: 2). He suggests that the slum is one of the primary results of modernisation in developing countries. Due to the hybrid intensity of the slum, which mixes fractured family units of various castes, ethnicities and religions who have migrated at differing times, the culture of the slum is constantly changing and adapting while trying to maintain a connection to the past through the continuation of tradition. It also struggles under the stress of the aspirations for modernisation and the influence of mass media and the strive for economic elevation. According to Nandy the slum responds in two ways: firstly it 'recreates the remembered village'; secondly it 'creates its own culture out of the slum itself' (1998: 6, 7). He argues that these two responses can also be seen in the popular cinema which produces content that contains 'everything – from the classical to the folk, from the sublime to the ridiculous, and from the terribly modern to the incorrigibly traditional' (1998: 7).

This view of the popular cinema as having a specifically socio-cultural and even political role in articulating the position of a particular section of society which may otherwise have little or no access to the public arena is both enticing and exciting as it authenticates the serious study of this cinema which Nandy describes as 'the disowned self of modern India returning in a fantastic or monstrous form to haunt modern India' (ibid.).

His description is a suggestive reminder of Siegfried Kracauer's work in *From Caligari to Hitler* (1947) on the role of Expressionist film in pre-Nazi Germany where the themes of monsters and madmen visualised through the use of chiaroscuro and stylised performance are seen as reflections and manifestations of particular political insecurities and turmoil. Nandy's argument is particularly convincing if we think of the cinema as a product of modernity drawing and transgressing from the past, moulding and remoulding representations as well as maintaining and challenging social values and morals. These notions are played through and even embodied in Bollywood's star system.

Stars are at the epicentre of Bollywood films, holding more importance than the directors, producers and all other aspects of the filmmaking process. Unlike Hollywood studios, which tend to block-book stars for individual productions, Bollywood relies on a 'shift system'. This allows a star to work simultaneously on a number of films by sharing their working day out between numerous projects (see Dwyer 2000a: 118). This method of working feeds into one of the general assumptions that the industry lacks a controlled and coherent system of production with many areas working separately from one another with schedules at the mercy of stars who hold a disproportionate amount of sway.

Richard Dyer suggests that charisma is one of the key signifiers of star quality (1998: 30–2). Charisma is found where an individual both entices interest and exudes importance as they signify particular cultural values, which are deemed appropriate by a society at a given time. The issue of charisma is important in Bollywood where films act as vehicles maintaining the perception of a particular star. This may include an association with specific genres and character types creating a sense of continuity around a specific star. The importance of this type of charisma is also demonstrated in the film poster, which rarely names the stars in the film as their iconic image means that they are easily recognisable. The icon is also allegorical, carrying specific connotations relating to stardom, genre, character, style and even morality.

It is important to investigate how stars and their appearance present specific ideals of 'Indian-ness' and how these are relevant to contemporary developments in wider society. Rachel Dwyer argues that beauty is an essential ingredient for the industry's film stars with the north Indian upper-caste Hindu being the traditional epitome of beauty for both men

and women, based on common ideas of physicality including height and fair skin (2001: 120–1). Fairness is traditionally associated with the higher castes, who do not partake in outdoor work and so are not exposed to the harshness of the sun. It is therefore associated with higher economic, cultural and social status. Images of gods, goddesses, saints and historical figures in calendar art always have fair skin. Culturally, darker skin tone may be a cause for concern, particularly for the parents of a young woman of marriageable age as some may consider dark skin to be socially unattractive and even a sign of bad luck.

One of the most widely used cosmetics in India is Fair and Lovely, a cream which has skin-lightening properties. Fair and Handsome, a skin-lightening cream aimed at men is advertised by one of Bollywood's biggest stars – Shah Rukh Khan. The romantic hero has often been played by fair-skinned heroes and this is particularly true of the teenage romantic hero such as Rishi Kapoor in *Bobby* and more recently, Shahid Kapoor. However, some of the major male stars, including Amitabh Bachchan, Sunil Shetty and Akshay Kumar, have skin tones which are darker than many of the other male stars. These stars are particularly popular amongst the masses outside of the middle-classes and whilst they have played romantic heroes, they are also known for their roles as underdogs, fighters for justice and action-men.

CASE STUDY: Deewar (Yash Chopra, 1975) / *Vivah* (Sooraj R. Barjatya, 2006)

Deewar is the story of two brothers, Vijay (Bachchan) the eldest brother, and Ravi (Shammi Kapoor), who come to Bombay as children with their mother after their father leaves them following his being framed by businessmen who wished to contain his trade union activities. Vijay himself suffers much humiliation both before and during his life in Bombay, most importantly his arm being forcefully tattooed with the line '*Mera baap chor hai*' ('My father is a thief') by workers who feel they have been abandoned by his father. From working as a maligned shoe cleaner and dockworker he enters the Bombay underworld where he finds respect, success, money and also acceptance when he falls in love with the prostitute Anita (Parveen Babi). In the meantime Ravi, who is supported through his studies by Vijay, completes his education and trains to be a policeman.

Amitabh Bachchan as Vijay, one of his many 'angry young man' roles. Poster for *Deewaar*. © Trimurti Films Pvt Ltd

Amitabh Bachchan is Bollywood's biggest star. His tall, lean body and deep voice marked him as physically different from his contemporaries. Bachchan has displayed an ability to perform a huge variety of characters and this accounts for much of his appeal, success and longevity as both an actor and a cultural icon. As mentioned above, one of the most iconic character types to emerge from Bollywood was the 'angry young man', seen primarily in Bachchan's films of the 1970s to 1980s. The 'angry young man' was an urban figure both wronged and rejected by society, often from childhood. He had to suffer incredible hardship, often including public humiliation and physical violence. The main purpose of his life was to restore his family to an economically comfortable position and/or create a sense of his own nuclear family. However, the means of achieving this aim often involved some form of criminal activity that promised success but went against the values of those around him be they family or figures of the state.

Ranjani Mazumdar (2000) describes the 'angry young man' figure both as a 'register of pain' and as a symptom of particular socio-political turbulence in India during the 1970s, with Bachchan's iconic status in the role being constructed not only from this situation but also from the construction of the persona through his own acting skills and particular ways of filming, such as tableaus composed of a series of long shots followed by a zoom to show the face.

Another of Bachchan's appeals in this role was his mastery of delivering dialogue, which in many cases of the 'angry young man' film was written by the aforementioned Salim-Javed. The dialogue in these films was

often simple, factual and direct. When words are delivered they seem to erupt out of the characters. One way of interpreting this is seeing the dialogue as a symptom of a specific type of male whose own emotions have been stifled through the traumas he has experienced. This again works in building characters that are symbols of rebelliousness and ideals of hyper-masculinity – these are men of action, not words. This latter factor is strengthened because the dialogues contain words that are violent: order and commands, profanities and swearwords.

Following in the tradition of the good and bad brothers, *Deewar* places particular emphasis on the two sons' relationship to their mother. The bad son (Vijay) desperately needs the love of his mother but she disowns him due to his criminal activity and she stays with her younger son. In one of the most famous lines of Bollywood cinema, Vijay accuses his brother of having no material wealth to which he replies *'Mere paas maa hai!'* ('I have a mother!'). This cuts Vijay to pieces, but his mother is never able to completely disown him as seen in the final scenes when she cradles him like a child as he dies in her arms.

The physical look of Bachchan's urban hero of the 1970s and 1980s is in grand contrast to that of recent male heroes whose roles now largely focus on the romantic young male. These heroes often portray a hysterical and contradictory portrayal of masculinity where a gentle, feminised exterior betrays an underlying super-muscular masculinity ready to jump into action to prove its worth. The heroes of Sooraj R. Barjtya's films differ as they celebrate men who are gentle, loving and caring whose appeal is in their emotional strength.

Vivah tells the story of the engagement between Prem (Shahid Kapoor) and Poonam (Amrita Rao). Prem is the son of a wealthy Delhi businessman. Poonam's parents died when she was a child and she lives with her uncle and his jealous wife who have one daughter called Rajni (Amrita Prakash). Prem's and Poonam are introduced, fall in love and agree to be married, but during the preparations for the marriage a fire ensues and engulfs the bride-to-be's home. Poonam returns to the house to rescue Rajni but as they leave a beam falls on Poonam, trapping and leaving her with severe burns. The doctor warns Poonam's uncle that even a daughter's own family will abandon their daughter after such disfiguration, suggesting that the marriage may need to be considered broken. This is not the case as Prem arrives with his family to the hospital with a pot of *sindoor* and places

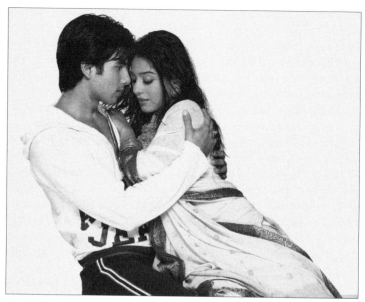

Prem (Shahid Kapoor) holds Poonam (Amrita Rao) in a romantic and protective embrace. Still from *Vivah*. © Rajshri Productions

the bridal mark on Poonam before her surgery. In a poignant moment the surgeon praises Prem's behaviour, claiming that the only new brides that he had previously treated were victims of domestic violence. The groom's family takes on the responsibility for her treatment and the ceremonies recommence.

The film is very much concerned with notions of beauty. Culturally, it can be argued that there is a connection between the beauty of Prem's physical appearance and his inner, emotional beauty. Prem's fairness is not just a physical ideal nor does it simply denote high caste, wealth and health. It is also a moral signifier. Fairness represents goodness, chasteness and purity and submission to tradition. One of the reasons for the aunt's jealousy is Poonam's physical beauty that is compared to that of her own daughter, who is unable to find a suitor due to her dark complexion. At several points in the film she is seen caked in skin-lightening products. Following Poonam's injuries, love is shown to override the traditional importance of the bride's physical beauty, particularly through Prem's

changing of Poonam's burns dressing, which is seen as an act of love and protection and beyond duty.

Audiences and Consumption

There are various ways in which audiences can track the stars beyond the cinema screen including magazines, consumer goods, live-shows and the internet. Richard Dyer has suggested that a star image is influenced by numerous factors that include promotion, publicity, films and finally, criticism and commentaries (1998: 60). Promotion is defined as officially released material which creates and maintains the star image, such as press releases and campaigns. Publicity differs as it is defined as 'what the press finds out' (ibid.) during interviews and it may contradict with the image that has been officially created. Criticism and commentaries are defined as the profiles and observations written and made about the stars during and after their lifetime. These two latter issues are particularly important when looking at Bollywood cinema due to the difficult relationship between stars and morality that is often the focus of gossip columns and magazines, Internet fan sites and the blogosphere. As Behroze Gandhy and Rosie Thomas note, the observations and commentaries of stars often contradict the ideal behaviour that they display on the screen (2000: 108).

The three most established and popular magazines for Bollywood fans are *Stardust*, *Cineblitz* and *Movie* (see Dwyer 2003: 168–98). These glossy, full-colour magazines provide industry news, interviews, photos and gossip on those in the film world. The gossip round-ups appear at the front of the magazines. In *Stardust* this section is entitled 'Neeta's Natter' and includes strategically placed pictures of bejewelled black cats. 'Neeta's Natter' also rewards the star who has recently shown the 'cattiest' behaviour with a monthly 'Cat's Crown'. A similar column in *Movie* magazine is wonderfully entitled 'Claws' and again contains strategically placed images, this time of a woman's hands with long and vampish nails. Interestingly, all of these magazines come in English. They use a particular type of English which combines English with Hindi and words from other languages such as Gujarati or Urdu. Their use of this language suggests that they are made for middle-class and affluent Indians as well as readers abroad. This theory is supported by the type of advertising found in the magazines, including clothing and beauty products and individuals providing services in palm-

istry and astrological readings. *Stardust* includes a section where fans may write in to stars in English asking specific questions about their films. The letters are published beside a picture of the star and their reply. There are also specific features on stars that may include a focus on a recent split or industry-spat. These are often accompanied by candid shots of the individual(s) concerned and there may also be publicity shot or more if the second individual involved is also a star.

Beyond magazines, fans may also purchase copies of films for themselves. VCDs have had a massive impact on the national market for the past ten years. Although digital, the quality of VCDs is more like that of a video than a DVD and the film is normally divided between two discs. Relatively speaking, DVDs cost much more and are therefore less widely available apart from the new upmarket 'Western-style' entertainment stores such as Rhythm House and Planet M found in major metropolitan areas. The continued popularity of VCDs is further evidenced by many films failing to make it onto DVD – this is particularly true of older titles and specific genres which are abundant in the VCD market such as the Mythological and films from the wider B-movie circuit such as horror films.

Bollywood film piracy is an international business costing the industry millions in lost revenue. It is difficult to say where and by whom the piracy business is being practiced although there are often reports of links to Pakistan,[1] Mumbai Dons and even terrorist organisations. The piracy business seems to be a mixture of organised and individual crime. A walk through the markets of Old Delhi and central Mumbai reveals the extent of the problem. Although fakes are easily recognisable either because they are new releases or due to poor printing on the packaging, the number of competing stands offering unofficial copies is quite staggering and one has to sift through these stalls to locate sellers with exclusively legal produce. In the UK illegal copies are sold on streets in shopping areas where there are major communities of people of South Asian origin. The Internet has become another area for unscrupulous bootleggers to sell illegal copies to unsuspecting customers. Yash Raj Films has worked in conjunction with local police to crack down on piracy and their website regularly reports on success stories.

Televisions are now owned by most homes, even those of the lower working classes. There seem to be as many channels and many of these are exclusively film-based, often Hindi but also regional film channels. These films are interrupted by adverts and may have extra advertising

seen in moving banners set across the bottom of the screen. Additionally the movies often contain the producer or distributor logo in the corner, perhaps in an attempt to curb piracy. Undoubtedly this all has an impact on the viewer's experience of watching the movie. However, home-cinema viewing is a very different experience to that of a movie theatre. My discussions with viewers in India revealed that the presence of advertising has little or no impact on viewers who are more effected by the content of the film itself (dropping in and out of songs) or external factors such as visitors to the home, chores and daily rituals.

Most Indian channels have some film-related content. State-run and lifestyle channels show programmes based around film songs. These may follow particular themes such as specific directors, actors, styles of music or themes. Film-based magazine programmes and interview shows are also abundant such as *Koffee with Karan*. In addition news channels have their own film-based features. One of the most popular games in India is *antakshari* where one competitor sings a verse or chorus of a song and the word on which they finish has to be used by their competitor as the first line of their chorus or verse. This game is often played using film-songs and so competitors are required to have an incredibly thorough knowledge of film music and lyrics, as do the musicians who must pick up the tune in an instant. *Antakshari* has mutated into a hugely popular game-show as its content is orientated towards the extended family with competitors being allowed to pick songs from across the ages.

Diaspora Audiences

Bollywood films have always been shown where people of Indian origin have settled. Following the arrival of Indian migrants both from India and East Africa to the UK in the mid-1960s and early 1970s, Bollywood enjoyed an increased distribution in the UK, showing in cinemas catering specifically to these communities. The films became a way for migrant communities to maintain a sense of cultural continuity. Unfortunately, many of these cinemas were closed with the arrival of video.[2] While the advent of video had an adverse effect on the industry, video distribution exposed audiences in the Diaspora to a wider variety of films, including 'golden oldies' imprinted in the minds of earlier generations who could at last share their favourite films with a new generation. Mythological films were

mandatory family viewing to teach Hindu myths with the added bonus of (bad and kitsch) special effects for entertainment. Regional language films such as Gujarati films were also available, and these were particularly popular amongst women. Interestingly, the viewing of Bachchan films was only appropriate amongst men and boys due to the violence, language and what could be viewed as derogatory, but definitely untraditional, representations of women. This was particularly important for those who were fighting to retain a sense of 'Indian-ness' and Indian values in a foreign clime, even though they may have not been in India, and/or whose ideas of India were perhaps anchored in the colonial India – most British Indians having their roots in economic migrations from India to British East Africa in the inter-war years.

These viewing experiences changed again in the 1990s with the return of romantic films that were immediately deemed appropriate for family viewing. These narratives also dealt with issues facing the Diaspora who, although now settled and increasingly confident in their positions, still faced moral crossroads where they were trying to negotiate Indian traditions with 'Western ways'.

A big part of fan culture for the Diaspora is attending live shows that take place in stadiums and arenas across the globe. These shows are a mixture of the variety show and Western pop concerts with the names of the events including titles such as 'Rock Stars', 'Heartthrobs' and 'Star Wars'. They normally feature two or three playback singers and several film stars but usually only one or two major players, the others being minor celebrities. There is live music and usually a troop of dancers to provide a backdrop for musical numbers. However, the main aim of attending these concerts is seeing the stars in real life and hearing them talk and converse with the audience. The repertoire of the playback singers will include both songs they had originally sung alongside cover versions. The actors repertoire is more eclectic and further blends the division between dramatic fantasy and reality. They may re-enact memorable scenes from their movies, old and new, complete with dramatic synths and voice enhancement. The appeal of this particular type of performance seems difficult to understand as the verisimilitude of the film song created through the combination of sets, camera angles and editing is immediately broken down and in doing so, the star quality of the personality fades as the apparatus of their construction is either missing or revealed. When attending a Western rock or

pop concert the main reason is to see the star and hear them live and when a star mimes, the audience usually complain of being ripped off or being cheated. This never occurs in the contexts of these shows as the star does not actually sing in the first place. In effect the experience of the event echoes – albeit distortedly – the experience in the cinema hall.

This type of unabashed exposure on the stage can leave us wondering about the reasons why seeing the star in such a fake context would be fascinating. The culture of fandom is an obvious place to look for an answer. For a fan to say they have seen their favourite star in the flesh can fill them with a sense of pride. Another reason is the emphasis on visual pleasure, to merely enjoy the spectacle of the star who may be a pin-up for the fan, a factor that makes the enjoyment in their appearance over-ride any irregularities in the vocal performance. Maybe it is exactly this breakdown of the star construction and cinematic apparatus that is appealing. To see the star in a more organic state, talking to the audience and dancing specifically for them creates a more personalised relationship between fans and star, especially when the style of the Bollywood movie can be melodramatic, romantic and fantastic. The appeal of the organic presence of the star is further evidenced by the online presence and sharing of pictures and video files of performances recorded on mobile phones during these events. These shows also double as community events, bringing together local but also disparate members of the Indian and wider South Asian community who also enjoy these films and adore the stars. Other stars may also be present for example comedians or singers from the Brit-Asian or 'Desi' pop scene.

The Internet has provided fans with a new outlet for gaining and sharing information, trivia and pictures relating to the industry, films and stars. The number of hits one receives when 'Bollywood' is typed into Google is astounding – over 600,000,000. There are several types of internet sites which fans use that include the official websites of Bollywood studios; websites for television channels which feature Bollywood items in their regular output; generic Bollywood fan-sites which have gossip columns, discussion forums and galleries, and finally star-specific websites which may be officially endorsed by stars or fan-made. While these sites may provide the opportunity for an individual to discuss their passion for films and stars it should also be taken into account that the websites can also be a private space where the individual may fake their identity or partake

in guilty pleasures: users may share gossip, magazine scans and screen-grabs. Fans may also create and share their own artworks and wallpapers. Through the use of retouching, digital effects and the dissecting of original images the sense of awe for the star and in turn the sense of awe s/he exudes is enhanced, and parallels can be drawn between these images and the calendar images of the divine. The social networking site Facebook has many groups that have been set up to both praise and berate stars, celebrate films and share information on up and coming releases. These groups allow fans to share information, pictures, provide links via YouTube and host discussion forums. Groups have also been set up on the influences of films, for example 'Bollywood Gave Me Unrealistic Expectations About Love'. Bollywood has recognised the power of the Internet to reach audiences and monetise on its assets. In 2006, *Vivah* became the first Indian film to be released simultaneously in cinemas and the Internet. The online release was made available as an encrypted download that automatically disintegrated after four days. By the end of the year, the total number of downloads reached four million. The main consumers were the Diaspora at whom this version was targeted.

Bollywood has had a huge impact upon gay and lesbian culture, particularly amongst the Diaspora. At first this may seem ironic due to the idea that Bollywood may promote a conservative, heterosexual worldview, based on traditional values of the family unit and adherence to social duty above personal desires. The issue of the acceptability of homosexuality in India is highly contestable. Until recently, homosexuality was classed under Section 377 of the Indian Penal Code as punishable by imprisonment. This law was introduced during the period of British colonisation and current gay Hindu organisations see it as a foreign implementation and even the antithesis of traditional Hindu views on gay, lesbian and transgender sexualities that are classed as *tritiya-prakriti* in Vedic scriptures.

In much the same way that icons from Hollywood were adopted by gay culture in North America and Europe, the appropriation of female icons from Bollywood has been particularly significant. Actresses who were famous for their tragedy roles as well as their tragic lives, such as Madhubala and Meena Kumari, are most obvious and the mention of the latter's swansong film *Pakeezah* (Kamal Amrohi, 1972) has become a signifier for the declaration of one's sexuality. The overtly theatrical performances of Rekha, Sri Devi and Madhuri Dixit remain equally popular with drag performers performing

their favourite musical numbers from their movies. I would argue that the influence of male stars upon this gay Asian Diaspora has been less significant, but it has risen since the emergence of a more metrosexual appearance amongst film stars. This has also propelled the popularity of male stars amongst the wider gay community as gay websites, blogs and forums often feature profiles of stars. Out of all films it is those which feature the character of the courtesan that have been most popular amongst gay audiences. The courtesan tradition harks back to an era which saw its heyday during the Mughal period and slowly died out during British colonial rule. Courtesans were not prostitutes but instead highly skilled women who were tutored in the arts from a young age. Instrument playing, singing, poetry and intellectual conversation were all essential requisites for the desired courtesan who would often be cared for by a personal patron. Set during the siege and fall of Lucknow to the British, *Umrao Jaan* (based on the life of a real courtesan) is one of the most famous courtesan films. The heroine and film's namesake (played by Rekha) is the most celebrated courtesan in the city. In many ways, she becomes a metaphor for the city whose beauty and cultural value is degraded, banished and ruined. But why should a historical and heterosexual female figure have such a huge interest for gay fans?

Whilst the narratives of courtesan films feature highly glamorous, beautiful women celebrated for their artistic skills, these heroines are hugely tragic characters, socially ostracised by traditional society and unable to sanctify their love, let alone spend their time with those they love. In *Umrao Jaan* the tragedy is not just personal but also societal and national, making the situa-

Publicity poster for *Pakeezah* featuring Meena Kumari as the film's namesake and the quintessential courtesan. © Mahal Pictures Pvt Ltd

tion depressingly heartbreaking, unavoidable and without escape. There are obvious parallels with homosexuality as a love that dare not speak its name, especially within a wider society with conservative values. However, the ability to relate to *Umrao Jaan*'s character also allows for ironic moments of tragic relief as the character of the courtesan becomes a conduit through which to express repressed desires.

CASE STUDY: *Awaara* (Raj Kapoor, 1951) / *Pakeezah* (Kamal Amrohi, 1972)

Bollywood films have been hugely popular outside of India beyond the Diaspora. This was particularly true of in the 1950s where the films and their stars were huge throughout Central Asia, Africa and the Middle East. *Awaara*, a tale of a poor man with a heart of gold and strong family values fighting the corrupt rich, was a popular film throughout the communist world; the film was a favourite of Chairman Mao and its stars Nargis and Raj Kapoor also became huge stars in the Soviet Union (see Chatterjee 2000: 77).

Following her kidnap by Jagga (K. N. Singh), Judge Raghunath (Prithviraj Kapoor) accuses his wife Leela of having an affair and throws her out despite her being pregnant. The scene is set to a song recalling Rama's banishment of his pregnant wife Sita, in the *Ramayana*. Leela moves to the slums with her baby who she names Raj and manages to send him to school where he befriends the upper-class Rita who is the charge of Judge Raghunath. He stops the two from being friends but they always have a place in each other's hearts. As adults Raj (Raj Kapoor) becomes embroiled in the underworld where he works for Jagga. Discovering the truth of Jagga's involvement in his family breakdown Raj kills Jagga. Rita (Nargis) acts as his lawyer in a court that is presided over by Raghunath, bringing father and son face to face with one another. Raj is jailed for the murder but a new life with Rita awaits him on his release.

Whilst the characters and plot celebrate the common man and his ideals, the film is best remembered for its incredible and surreal dream sequence based around the song '*Ghar Aaye Mera Pardesi*' ('My travelling lover has returned home'), a fantastic visualisation of Raj's moral struggle. Raj first appears trapped in the claws of a monstrous devil and later skeleton (representing the evil Jagga), but escapes to find Rita in the guise of a dancing *apsara* (celestial nymph) representing hope, release and a

way out of the predicament as she is surrounded by massive statues of the Hindu god Shiva. These including his all-seeing three-headed form (*Trimutri*) and his dancing form (*natraj*), representing the eternal cylce of birth and death.

Pakeezah is a beautiful costume drama set in the fading world of the courtesan at the turn of the twentieth century. The courtesan Nargis dies after giving birth to an illegitimate daughter. The baby is adopted by her aunt and grows to become the celebrated courtesan Sahib Jaan (Meena Kumari). Salim (Raaj Kumar) sees Sahib Jaan's feet on a train journey and falls in love with her. Following a boat accident caused by a herd of maddened elephants, Sahib Jaan is rescued by Salim but then, unbeknown to him, she is found by her aunt who takes her back to the city. Their paths cross again when Sahib Jaan is almost killed by a train. Salim offers Sahib Jaan a free life by offering to marry her, but following a series of public humiliations she returns to her life as a courtesan and performs a dance at Salim's pre-wedding celebrations. During her performance, she smashes a glass candelabra and begins to dance on the shattered pieces. The crimson blood from her feet (once the fetishised object of desire) stains the pure white sheets decorating the floor. This dramatic performance is a physical expression of her emotional turmoil and a hysterical reaction to her entrapment in her life as a courtesan. The hysteria is heightened in the loosening of her hair and the unleashing of her veil, both of which give her a ghost-like quality. Ultimately, a series of bloody revelations leads to her discovering the true identity of her father which has consequences that will change her life.

Both *Pakeezah* and Meena Kumari have become important in gay culture. The narrative of this courtesan film and others such as *Umrao Jaan* gives us insights into their particular appeal to gay audiences. The key protagonists lead suppressed lives and are in forced conditions, hiding a love that dare not speak its name. They are publicly mocked and derided when in public. Sahib Jaan's almost hysterical need for escape from her trapped predicament (symbolised by a bird kept in a gilded cage) is continually stifled by both those who know her and those who do not, being an outsider in whatever circles she finds herself. Her emotional condition is such that she cannot receive acceptance even when she is offered a hand in marriage and instead she hysterically screams and runs away. However, the film offers hope in its ending which sees Sahib Jaan receiving delivery from

her predicament, an ending that is bittersweet but a promise of escape none the less.

Notes

1 See http://blogs.ft.com/beyond-brics/2012/01/25/pakistan-more-bollywood-please/#axzz27IGaArwX
2 It is difficult to say whether film-viewing practices became more insular. My personal experiences suggest that the practice was not insular but still communal as viewing would take place within the home but members of the extended family and friends would be invited to watch the film and these were often family events with food, drinks and gossip an essential part of the viewing experience.

CONCLUSION: BYE-BYE BOLLYWOOD?

This book has aimed to demonstrate that Bollywood has produced a variety of genres, themes, characters and stylistic conventions. Once the basic rationale behind these is understood, the films can be appreciated and understood in full. I have also noted how Bollywood has mutated and shifted through time, as a reaction to technological, socio-political and cultural changes providing an opportunity for Indians and India (as well as those of Indian origin around the world) to negotiate change. As has been seen, Bollywood has been a thriving industry but one which has also had moments of crisis. Today, more than ever, it does seem that Bollywood is again in crisis and perhaps passing into a new age which is being heralded by changes within the industry, wider – national and international – cultural influences and also new methods of consumption beyond the traditional cinema hall.

Today, India's cinema halls vary from single-screen halls which have an exclusively male clientele through to standard family-oriented cinemas with areas split by ticket price. At the peripheries are the mobile cinemas used in rural areas that pitch up in different villages every night and at the opposite end of the spectrum are the multiplex cinemas which are booming in urban centres. Mumbai has a significant number of historical cinema halls that have long served the industry as venues for premieres. These include the Regal, Liberty and Eros. These three cinemas were built during the colonial period and all have been recently renovated to compete with the high standards set by multiplexes. These charge higher ticket prices

and cater to the middle and upper classes. The vast revenue earned from multiplex tickets is also having an increasing impact upon film production – in particular films about Non-Resident Indians (NRIs).

The arrival of multiplex cinemas is also changing viewing practices. The films shown here often feature NRIs and the upwardly mobile Indian, and in many cases the city and country of the film's creation seems to be invisible. Whilst these narratives offer spectacles, pleasures and allow for the negotiation of issues which may be difficult in an Indian setting, the question that also needs to be asked is are the films alienating the larger population in India: if Bollywood now primarily caters for the internationally placed and upwardly mobile Indian, providing them with particular ideals of lifestyle and glamour and discussing issues reflecting their particular experiences, can it still be classed as popular? My answer is yes. The distribution of the industry's films goes beyond the cinema screen infiltrating all aspects of popular culture, most obviously popular music. Also, while the multiplexes may be fragmenting audiences, the films are widely seen in the established single-screen cinema halls and the widespread availability of VCDs and movie-based TV channels ensures their distribution and continued viewing.

Smaller cinemas are emerging which are offering alternatives. One of these is what I would call a Mumbai New Wave aimed at the young, urban and educated middle classes – films by young directors outside of the larger studios who create films around grittier issues where the focus is more on drama than melodramatic traditions, but they still maintain some Bollywood elements such as songs and may even involve Bollywood stars and producers. These include films such as *My Brother Nikhil* (Onir, 2005) dealing with homosexuality and AIDS in the 1980s or *Iqbal* (Nagesh Kukunoor, 2005), the moving story of a deaf boy's dream to play cricket in the national team, produced by one of the industry's biggest players Subhash Ghai and his Mukta Searchlight Films.

It is too early to tell whether these are new directions for the wider Indian film industry or whether the popular cinema of Mumbai will need to follow suit. But as India itself goes through massive economic, social and cultural changes, and as India celebrates a century of feature filmmaking, it will be fascinating to witness what the song and dance will be in the future.

FILMOGRAPHY

Aan (Mehboob, 1953)
Aasha (M. V. Raman, 1957)
Amar Akbar Anthony (Manmohan Desai, 1977)
Andaz (Mehboob Khan, 1949)
An Evening in Paris (Shakti Samanta, 1967)
Anmol Ghadi (Mehboob Khan, 1946)
Aradhana (Shakti Samanta, 1969)
Awaara (Raj Kapoor, 1951)
Babul (S. U. Sunny, 1950)
Baiju Bawra (Vijay Bhatt, 1952)
Bandh Darwaza (Shyam and Tusli Ramsay, 1990)
Bandini (Bimal Roy, 1963)
Barsaat (Raj Kapoor, 1949)
Barsaat Ki Raat (P. L. Santoshi, 1960)
Bobby (Raj Kapoor, 1973)
Boot Polish (Prakash Arora, 1958)
Border (J. P. Dutta, 1997)
Caravan (Nasir Hussain, 1971)
Chandni (Yash Chopra, 1989)
China Gate (Rajkumar Santoshi, 1988)
Coolie (Manmohan Desai, 1983)
Deewaar (Yash Chopra, 1975)
Devdas (Bimal Roy, 1955)
Devdas (Sanjay Leela Bhansali, 2002)

Dharamputra (Yash Chopra, 1961)
Diamond Queen (Homi Wadia, 1940)
Dil Chahta Hai (Farhan Akhtar, 2001)
Dil Ek Mandir (C. V. Sridhar, 1963)
Dil Se (Mani Ratnam, 1998)
Dil To Pagal Hai (Yash Chopra, 1997)
Dilwale Dulhaniya Le Jayenge (Aditya Chopra, 1995)
Do Aankhen Baarah Haath (V. R. Shantaram, 1957)
Do Bigha Zamin (Bimal Roy, 1953)
Don (Chandra Barot, 1978)
Don (Farhan Akhtar, 2006)
Do Raaste (Raj Khosla, 1969)
Dosti (Satyen Bose, 1964)
Dr Kotnis Ki Amar Kahani (R. V. Shantaram, 1946)
Fanaa (Kunal Kohli, 2006)
Fiza (Khalid Mohamed, 2000)
Gadar – Ek Prem Katha (Anil Sharma, 2001)
Guide (Vijay Anand, 1965)
Guddi (Hrishikesh Mukherji, 1971)
Gunga Jumna (Nitin Bose, 1961)
Haathi Meri Saathi (M. A. Thirimugham, 1971)
Har Har Mahadev (Chandrakant, 1974)
Hare Rama Hare Krishna (Dev Anand, 1971)
Howrah Bridge (Shakti Samata, 1958)
Hum Aapke Hain Koun…! (Sooraj R. Barjatya, 1994)
Insaf Ka Tarazu (B. R. Chopra, 1980)
Iqbal (Nagesh Kukunoor, 2005)
Jai Santoshi Maa (Vijay Sharma, 1975)
Jewel Thief (Vijay Anand, 1967)
Jhanak Jhanak Payal Baje (R. V. Shantaram, 1955)
Jhansi Ki Rani (Sohrab Modi, 1956)
Jodha Akbar (Ashutosh Gowariker, 2008)
Junglee (Subodh Mukherji, 1961)
Kaagaz ke Phool (Guru Dutt, 1959)
Kabhi Alvida Naa Kehna (Karan Johar, 2006)
Kabhi Kabhie (Yash Chopra, 1976)
Kabhi Khushi Kabhie Gham… (Karan Johar, 2001)

Kaho Na… Pyaar Hai (Rakesh Roshan, 2000)

Kal Ho Naa Ho (Nikhil Advani, 2003)

Kashmir ki Kali (Shakti Samanta, 1964)

Khal Nayak (Subhash Ghai, 1993)

Kismet (Gyan Mukherjee, 1943)

Kohinoor (S. U. Sunny, 1960)

Koi… Mil Gaya (Rakesh Roshan, 2003)

Krrish (Rakesh Roshan, 2006)

Kuch Kuch Hota Hai (Karan Johar, 1998)

Lagaan: Once Upon a Time in India (Ashutosh Gowariker, 2001)

Lage Raho Munna Bhai (Rajkumar Hirani, 2006)

Lawaaris (Prakash Mehra, 1981)

The Legend of Bhagat Singh (Rajkumar Santoshi, 2002)

LOC: Kargil (J. P. Dutta 2003)

Madhumati (Bimal Roy, 1958)

Maine Pyar Kiya (Sooraj R. Barjatya, 1989)

Main Tulsi tere Aagan ki (Raj Khosla, 1978)

Mangal Pandey: The Rising (Ketan Metha, 2005)

Mere Mehboob (Harnam Singh Rawail, 1963)

Mohra (Rajiv Rai, 1994)

Mother India (Mehboob Khan, 1957)

Mr India (Shekhar Kapur, 1987)

Mughal-E-Azam (K. Asif, 1960)

Munnabhai M.B.B.S. (Rajkumar Hirani, 2004)

My Brother Nikhil (Onir, 2005)

Nagin (Nandlal Jaswantlal, 1954)

Nagin (Rajkumar Kohli, 1976)

Nagina (Harmesh Malhotra, 1986)

Nasseb (Manmohan Desai, 1981)

Navrang (R. V. Shantaram, 1959)

Naya Daur (B. R. Chopra, 1957)

Om Shanti Om (Farah Khan, 2007)

Pakeezah (Kamal Amrohi, 1972)

Pardes (Subhash Ghai, 1997)

Pinjar (Chandra Prakash Dwivedi, 2003)

Prapancha Pash aka *A Throw of Dice* (Franz Osten, 1929)

Pukar (Sohrab Modi, 1939)

Pyaasa (Guru Dutt, 1957)
Qayamat Se Qayamat Tak (Mansoor Khan, 1988)
Qurbani (Feroz Khan, 1980)
Ram aur Shyam (Tapi Chanakya, 1967)
Rangeela (Ram Gopal Varma, 1995)
Razia Sultan (Kamal Amrohi, 1983)
Sahib Bibi Aur Ghulam (Abrar Alvi, 1961)
Salaam Namaste (Siddharth Anand, 2005)
Sampoorna Ramayana (Babubhai Mistry, 1961)
Sangam (Raj Kapoor, 1964)
Satyam, Shivam, Sundaram (Raj Kapoor, 1978)
Satya (Ram Gopal Varma, 1998)
Seeta Aur Geeta (Ramesh Sippy, 1972)
Sholay (Ramesh Sippy, 1975)
Shree 420 (Raj Kapoor, 1955)
Silsila (Yash Chopra, 1981)
Swades: We, the People (Ashutosh Gowariker, 2004)
Taj Mahal (M. Sadiq, 1963)
Teesri Manzil (Vijay Anand, 1966)
Trishul (Yash Chopra, 1978)
Umrao Jaan (Muzaffar Ali, 1981)
Veer Zaara (Yash Chopra, 2004)
Vivah (Sooraj R. Barjatya, 2006)
Waqt (Yash Chopra, 1965)
Yaadon ki Baaraat (Nasir Hussain, 1973)
Zanjeer (Prakash Mehra, 1973)

BIBLIOGRAPHY

Ahluwalia (1981) *Tagore and Gandhi: The Tagore-Gandhi Controversy*. New Delhi: Pankaj Publications.

Bandyopadhyay, S. (1993) *Indian Cinema: Contemporary Perspectives From the Thirties*. Jamshedpur: Celluloid Chapter.

Barnouw, E. and S. Krishnaswamy (1980) *Indian Film*. New York: Oxford University Press.

Brooks P. (1995) *The Melodramatic Imagination: Balzac, Henry James, Melodrama and the Mode of Excess*. New Haven, CT: Yale University Press.

Bruzzi, S. (1997) *Undressing Cinema: Clothing and Identity in the Movies*. London: Routledge.

Cohan S. (1993) 'Feminizing the Song and Dance Man: Fred Astaire and the Spectacle of Masculinity in the Hollywood Musical' in S. Cohan and I. R. Hark (eds) *Screening the Male: Exploring Masculinities in Hollywood Cinema*. London: Routledge, 46–69.

Chakravarty, S. (1993) *National Identity in Indian Popular Cinema 1947– 1987*. Austin: University of Texas Press.

Chatterjee, G. (2002) *Mother India*. London: British Film Institute.

Chopra, A (2000) *Sholay: the Making of a Classic*. New Delhi: Penguin.

Dwyer, R. (2000a) *All You Want is Money: All You Need is Love: Sex and Romance in Modern India*. London: Cassell.

_____ (2000b) 'Bombay Ishtyle', in S. Bruzzi and P. Church Gibson (eds) *Fashion Cultures: Theories, Explorations and Analysis*. London: Routledge, 178–90.

_____ (2000c) 'The Erotics of the Wet Sari in Hindi Films', *South Asia*, XXIII,

2, 143–59.

_____ (2002) *Yash Chopra*. London: British Film Institute.

_____ (2003) 'Representing the Muslim: The "Courtesan Film" in Indian Popular Cinema', in T. Parfitt and Y. Egorova (eds) *Mediating the Other: Representations of Jews, Muslims and Christians in the Media*, London: Routledge, 78–92.

_____ (2005) *100 Bollywood Films*. London: British Film Institute.

_____ (2006a) *Filming the Gods: Religion and Indian Cinema*. London: Routledge.

_____ (2006b) 'The Saffron Screen?: Hindi Movies and Hindu Nationalism', in B. Meyer and Annalies Moors (eds) *Religion, Media and the Public Sphere*. Bloomington: Indiana University Press , 422–60.

_____ (2006c) 'Kiss and Tell: Expressive Love in Hindi Movies', in F. Orsini (ed.) *Love in South Asian Traditions*. New Delhi: Oxford University Press, 289–302.

Dwyer, R. and D. Patel (2002) *Cinema India: The Visual Culture of Hindi Film*. London: Reaktion Books/Victoria and Albert Museum.

Dwyer, R. and C. Pinney (2000) *Pleasure and the Nation: The History, Politics and consumption of Public Culture in India*. Delhi: Oxford University Press.

Dyer, R. (1998) *Stars*. London: British Film Institute.

Garber M. (1992) *Vested Interests: Cross Dressing and Cultural Anxiety*. New York and London: Routledge.

Gandhy, B. and R. Thomas (1991) 'Three Indian Film Stars', in C. Gledhill (ed.) *Stardom: Industry of Desire*. London: Routledge, 107–31.

Ganti, T. (2004) *Bollywood: a Guidebook to Bollywood Cinema*. London: Routledge.

Garga, B. (1996) *So Many Cinemas*. Mumbai: Eminence Designs.

Gledhill, C. (1991) *Stardom: Industry of Desire*. London: Routledge.

Gopalan, L. (1997) 'Avenging Women in Indian Cinema', *Screen*, 38, 1, 42–59.

_____ (2002) *Cinema of Interruptions: Action Genres in Contemporary Indian Cinema*. London: British Film Institute.

Inden, R. (1999) 'Transnational Class, Erotic Arcadia and Commercial Utopia in Hindi Films', in C. Brosius and M. Butcher (eds) *Image Itineraries: Audio-visual Media and Cultural Change in India*. New Delhi: Sage, 41–66.

Kabir N. M. (1997) *Guru Dutt: A Life in Cinema*. New Delhi: Oxford University Press.

Kabir, N. (2001) *Bollywood*. London: Film Four.

Kaskebar, A. (1999) 'An Introduction to Indian Cinema', in J. Nelmes (ed.) *An Introduction to Film Studies*. London: Routledge, 381–416.

____ (2000) 'Hidden Pleasures: Negotiating the Myth of the Female Ideal in Bollywood Cinema', in R. Dwyer and C. Pinney (eds) *Pleasure and the Nation: The History, Politics and consumption of Public Culture in India*. New Delhi: Oxford University Press, 286–308.

Kracauer, S. (1947) *From Caligari to Hitler: A Psychological History of the German Film*. Princeton: Princeton University Press.

Krishen, P. (ed). Indian Popular Cinema: Myth, Meaning and Metaphor. India International Centre Quarterly 8 (1) Special Issue: March 1980.

Mazumdar, R. (2000) 'From Subjectification to Schizophrenia: The "Angry Man" and the "Psychotic" Hero of Bombay Cinema', in R. S. Vasudevan (ed.) *Making Meaning in Indian Cinema*. New Delhi: Oxford University Press, 238–64.

Mishra, V. (1985) 'Towards a Theoretical Critique of Bombay Cinema', *Screen*, 2, 3–4, 133–46.

____ (2002) *Bollywood Cinema: Temples of Desire*. London: Routledge.

Mulvey, L. (1975) 'Visual Pleasure and Narrative Cinema', *Screen*, 16, 3: 6–18.

Nair, P. (1995) 'In the Age of Silence', in R. Vasudevan (ed.) *Frames of Mind: Reflections on Indian Cinema*. New Delhi: UBSPD, 3–16.

Nandy, A. (1981) 'The Bollywood Film: Ideology and First Principles', in M. Sinha, 'Indian Popular Cinema: Myth, Meaning and Metaphor', *India International Centre Quarterly*, 8, 1, Special Issue, 89–96.

____ (1995) 'An Intelligent Critic's Guide to the Indian Cinema', in *The Savage Freud and Other Essays on Possible and Retrievable Selves*. Princeton: Princeton University Press, 196–236.

____ (1998) *Secret Politics of our Desires: Innocence, Culpability and Popular Cinema*. London: Zed Books.

Nowell-Smith, G. (ed.) (1996) *The Oxford History of World Cinema*. Oxford: Oxford University Press.

Pendakur, M. (1990) *Indian Popular Cinema: Industry, Ideology and Consciousness*. Cresskill, NJ: Hampton Press.

Pinney, C. (2000) 'Public, Popular and Other Cultures', in R. Dwyer and C.

Pinney (eds) *Pleasure and the Nation: the History, Consumption and Politics of Public Culture in India*. Delhi: Oxford University Press, 1–34.

____ (2004) *'Photos of Gods': The Printed Image and Political Struggle in India*. London: Reaktion Books.

Pinto, J. (2006) *Helen: The Life and Times of an H-Bomb*. New Delhi: Penguin.

Prasad, M. (1993) 'Cinema and the Desire for Modernity', *Journal of Arts and Ideas*, 25–6, 71–86.

____ (1998) *Ideology of the Hindi Film: a Historical Construction*. Delhi: Oxford University Press.

Propp, V. (1968 [1927]) *The Morphology of the Folktale*. Austin, TX: University of Texas Press.

Rajadhyaksha, A. (1987) 'The Phalke Era', *Journal of Arts and Ideas*, 14–15, 47–75.

____ (1993) 'The Epic Melodrama: Themes of Nationality in Indian Cinema', *Journal of Arts and Ideas*, 25–6, 55–70.

____ (1996) 'Indian Cinema: Origins to Independence', in G. Nowell-Smith (ed.) *The Oxford History of World Cinema*. Oxford: Oxford University Press, 398–409.

____ (1996a) 'India: Filming the Nation', in G. Nowell-Smith (ed.) *The Oxford History of World Cinema*. Oxford: Oxford University Press, 678–89.

Rajadhyaksha, A. and P. Willemen (1999) *An Encyclopaedia of Indian Cinema*. London: British Film Institute.

Rangachariah, D. B. T (1928). *Report of the Indian Cinematograph Committee 1927–8*. Madras: Government Press.

Rangoonwalla, F. (1975) *75 Years of Indian Cinema*. New Delhi: Indian Book Co.

Sheth, A. and N. Sheth (1994) *Sangeet Bhavan Trust*. Bombay: Pankaj Mullick Music Research Foundation.

Stein, B. (1998) *History of India*. London: Wiley-Blackwell.

Tasker, Y. (1993) *Spectacular Bodies: Gender, Genre and the Action Cinema*. London: Routledge.

Thomas, R. (1985) 'Indian Cinema: Pleasures and Popularity. An Introduction', *Screen*, 26 (3–4): 61–131.

____ (1989) 'Sanctity and Scandal: The Mythologization of Mother India', *Quarterly Review of Film and Video*, 11, 11–30.

____ (1995) 'Melodrama and the Negotiation of Morality in Mainstream

Hindi Film', in C. A. Breckenridge (ed.) *Consuming Modernity: Public Culture in a South Asian World*. Minneapolis: University of Minnesota Press, 157–82.

Uberoi, P. (2000) 'Imagining the Family: An Ethnographic of Viewing *Hum Aapke Hain Koun…!*', in R. Dwyer and C. Pinney (eds) *Pleasure and the Nation: The History, Politics and consumption of Public Culture in India*. Delhi: Oxford University Press, 309–51.

Vasudevan, R. (1989) 'The Melodramatic Mode and Commercial Hindi Cinema: Notes on Film History, Narrative and Performance', *Screen*, 30, 3, 29–50.

____ (1993) 'Shifting Codes, Dissolving Identities: the Hindi Social Film of the 1950s as Popular Culture', *Journal of Arts and Ideas*, 23–4, 51–79.

____ (2000) *Making Meaning in Indian Cinema*. Delhi: Oxford University Press.

INDEX